traveling the spaceways

SUN=RA

The Astro Black and Other Solar Myths

Edited by John Corbett, Anthony Elms and Terri Kapsalis

ISBN 978-0945323150

Published by WhiteWalls, Inc., a not-for-profit corporation,
©2010 WhiteWalls, Inc. and the authors

WhiteWalls books are distributed by University of Chicago Press

WhiteWalls Editor
Anthony Elms

Design
Department of Graphic Sciences

Printed in China

The *Traveling the Spaceways* program is made possible with support from:

 Illinois Humanities Council

Cover: Unprinted LP cover. Courtesy Chicago Jazz Archive, Special
Collections Research Center, University of Chicago Library.

Back Cover: Portrait of Sun Ra by Plastic Crimewave (Steve Krakow)

Contents

Sun Ra
and his Solar Astro-Infinity Arkestra

Sun Ra's group is what happens when Astrology meets technology in the 21st century

Sun Ra's space music is a vast, sprawling, heterogenous mixture of everything that has happened in jazz from its earliest days right up through the experiments of the current avant garde and off into flights of fancy that are the products of the odd instruments that Sun Ra collects and his fascination with other-worldly sounds and thoughts.

THE NEW YORK TIMES

His space music, with its emphasis on extraterrestial vibrations, seems more than music; spiritual, almost religious in feeling, as if something more than the waves from a pulsar star, many light-years removed from us in the outermost boundaries of unmeasurable space, is tuning him in to a cosmic consciousness.

DOWNBEAT

Sun Ra is a sagacious man and it seems in character for him to organize the new jazz. The real point is that he has added a fresh and colourful accent to the language of new wave jazz and, in so doing, produced music of quality.

JAZZ JOURNAL, LONDON, ENGLAND

Sun Ra and his Arkestra performed a series of multi-media concerts billed as The Space Music of Sun Ra, at Carnegie Hall, Friday April 12 & Saturday April 13; twenty years after Sun Ra had introduced a newer reference and purpose into music by way of his Cosmic-Equations, evolving a music with an awareness of Space, Interplanetary beingness and motion towards infinity . . . a music he calls Astro-Infinity Music.

NEW YORK FREE PRESS

Saturn poster, early 1970s. Courtesy Chicago Jazz Archive, Special Collections Research Center, University of Chicago Library.

Introduction

BY JOHN CORBETT, ANTHONY ELMS AND TERRI KAPSALIS

This compilation of writings on and around Sun Ra is assembled primarily from presentations made during *Traveling the Spaceways: Sun Ra, The Afro-Black and Other Solar Myths*, a two-day symposium at the Hyde Park Art Center (HPAC), Chicago, in November, 2006. The occasion for this event was the inaugural installation of *Pathways to Unknown Worlds: Sun Ra, El Saturn & Chicago's Afro-Futurist Underground, 1954-68*, an exhibition curated by the three of us, that subsequently traveled to Philadelphia's Institute of Contemporary Art and the Durham Art Guild in North Carolina; and *Interstellar Low Ways*, an associated exhibition (in Chicago only) curated by Elms and art historian Huey Copeland, which gathered contemporary work by artists inspired in one way or another by Ra and his legacy.

Conceived and curated in a gradual manner starting in 2000, *Pathways to Unknown Worlds* was focused on a group of newly discovered historical materials, documents and artifacts drawn from the period Ra spent in Chicago, some of them extending into his later landings in New York and Philadelphia. HPAC accepted the proposed show in 2003, and the next three years were spent choosing, restoring, and preparing the historical materials, as well as researching, designing, and readying two precursor volumes dedicated to Ra, *The Wisdom of Sun-Ra* and *Pathways to Unknown Worlds*. The *Pathways* exhibition, featuring artworks, album covers, business ephemera and more from Saturn records hung in one of the intimate upstairs galleries at HPAC, with adjoining rooms in which films, music, and slides were screened. This material was augmented by the much more expansive, wildly eclectic *Interstellar Low Ways* exhibit, which occupied the voluminous, high-ceilinged main hall. This exhibition included artists Matthew Bakkom, Pedro Bell, Destroy All Monsters, Karl Erickson with Robby Herbst, Matthew Hanner, Alex Hubbard, Derek Jackson, Karl Heinz Jeron, Tim Kerr, Stephen Lapthisophon, Glenn Ligon, Dave Muller, Wangechi Mutu, My Barbarian, Senam Okudzeto, Joe Overstreet, Charlemagne Palestine, Adam Pendleton, Reverend Seymour Perkins, Mai-Thu Perret, Plastic Crimewave, Robert A. Pruitt, Simone Shubuck, Josh Smith, travis, Fatimah Tuggar, and Christopher Wool. Together, the exhibitions offered an excellent opportunity to invite a cadre of writers, artists and thinkers to contribute something new about Ra's music, his philosophy, his business activities, his artwork and poetry, and the influence of all of this on recent generations of artists.

From the start, the three of us concurred that *Traveling the Spaceways* should be more than a conventional academic conference. It would, we agreed, include leading authorities on Ra's music, such as his discographer, Robert Campbell, the NPR jazz journalist Kevin Whitehead, and the British writer Graham Lock, whose book *Blutopia* put Ra in a matrix of African-American musical and literary intellectualism. Ra's biographer, John Szwed, was also invited, though he ultimately was unable to attend; happily he would, however, lecture later during the ICA's festivities in Philadelphia. Reflecting our divergent backgrounds and expertise, it was decided that Corbett would present some thoughts on the early business of El Saturn Records, Kapsalis would

focus on Ra's wordplay and mysticism, and Elms would introduce some of the ways Ra might be meaningful for contemporary artists.

Limiting ourselves to only a weekend's worth of invited guests was difficult. We are thankful to those who made it and gathered for the symposium. Without a doubt it was essential to have Adam Abraham give a personal account of his father Alton Abraham's commitment and contribution to Ra and Ra's vision. With the wealth of original art and design from the record label, we thought it would be interesting to ask Victor Margolin to place these materials in a broad historical context of African-American commercial design in Chicago. Considering both the implications of Ra's iconographic omniverse and the startling array of artists drawn into Ra's orbit, it was clear we would be well served by inviting several contemporary artists (Malik Gaines, Glenn Ligon, Kerry James Marshall,) and a curator (Hamza Walker) to add their unique, divergent perspectives. With an eye on extending the conversation beyond music and art, we invited poet Calvin Forbes.

To have a Sun Ra event without some live performance element would be quite unsympathetic to the object of study. The symposium weekend started at the Hideout music venue with a performance by the group My Barbarian and an improvised trio of Thurston Moore, Jim Baker and Avreeyal Ra. Dramatist Cheryl Lynn Bruce began and ended the proceedings on both days of the symposium with dramatic and sensitive readings of Ra's tricky, provocative early broadsheets. Panels were convened in the cavernous space of HPAC's main hall, with works by Christopher Wool, Glenn Ligon and Destroy All Monsters serving as a backdrop. Between individual panel sessions were sets by David Boykin's Expanse, The Fred Lonberg-Holm Trio, Ken Vandermark's Sun Ra Composer Quartet, and a string-centered group led by Nicole Mitchell. During a later weekend, former Arkestra member Phil Cohran gave a commanding lecture/performance. All together, this was as rich a set of events as we could have hoped for, and it stirred ample interest in all things Ra. Which is exactly what we wanted.

Ra liked to joke that he was a great success—he'd been so successful at playing the low profile. In the sixteen years since his death, his profile has been on the rise. Our aim with these exhibitions, books, concerts, screenings, lectures and readings was to bring his work more centrally into art and academic discourse, where they already had considerable traction. Ra's basic working notions, starting in the 1950s, anticipated many of the focal points of today's cultural scene. His work was fundamentally interdisciplinary. It engaged its audience by means of spectacular staged social events that were relational in nature. And it was all based on an intense personal investment of time and energy in the activity of research—in fact one wing of the business was called Saturn Research and in an early sketchbook Ra and Alton Abraham fantasized about building an El Saturn research complex. For too brief a period in 2006-2007, the Hyde Park Art Center, close to where Ra had once lived on the South Side of Chicago, was precisely that: a Myth-Science Astro-Black Research Facility.

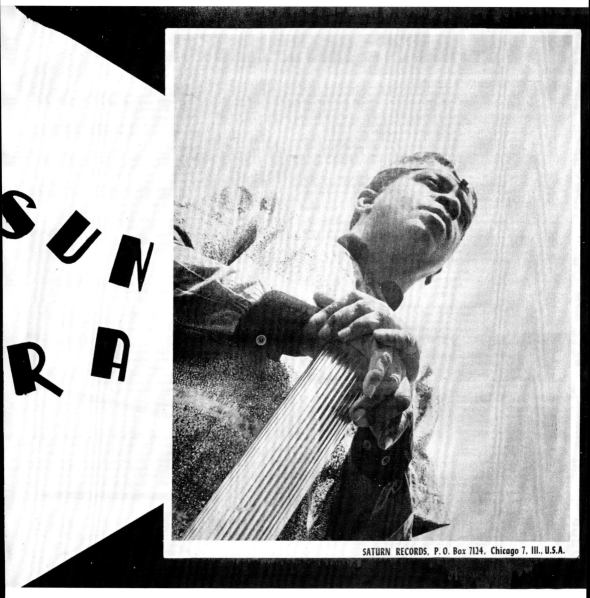

SATURN RECORDS, P. O. Box 7124, Chicago 7, Ill., U.S.A.

Saturn poetry broadsheet, c. 1967. Courtesy Chicago Jazz Archive, Special Collections Research Center, University of Chicago Library.

Aye, Black-light painting, c. 1972. Photograph courtesy Chicago Jazz Archive, Special Collections Research Center, University of Chicago Library.

Some Ra

BY CHERYL LYNN BRUCE

I.

> Men are so inevitably mad, that not to be mad would be to give a mad twist
> to madness.
> > —Blaise Pascal (1623–1662)

> The simplest and most general definition we can give of classical madness
> is indeed delirium. This word is derived from lira, a furrow; so that deliro
> actually means to move out of the furrow, away from the proper path of
> reason.
> > —Michel Foucault, Madness and Civilization: A History of Insanity
> > in the Age of Reason

> ...We should endeavor to show the world and ourselves our beautiful and
> powerful variety...
> > —Suzan-Lori Parks, The America Play and Other Works

When Sun Ra announced he was from Saturn…well…he got folks' attention.
An emissary from the remotest planet, he took his charge seriously

Wholesale Enlightenment. Unmask cosmic flimflam!

With eyes fixed firmly on the future, he peered beyond the outer realms
into divine truths because, he sagely counseled, "Space is the place."

II.

> ...Words are spells in our mouths...

> ...A spell is a place of great (unspoken) emotion...
> > —Suzan-Lori Parks, The America Play and Other Works

> Truly it has been said, that to a clear eye the smallest fact is a window
> through which the Infinite may be seen.
> > —Thomas Huxley, Huxley's Essays

Ra spoke spells
wove stellar visions/wild words into wholly irreverent cloth
marked by dueling patterns and thundering hues long on sheen.

Zig-zagging and definitely cut on the bias,
Ra liked his edges crisp but never hemmed in.
Outsized, his logic, fits when you get into it.

Ra wrote irregularly regularly.

Pitched his theories in arresting communiques,
bold broadsides that peeled one's hair and gave one pause,
epistles that bristled with knowings for all who dared heed them
once they'd caught their breath.

A heavenly haberdasher, Ra reigned in (but did not rein in) sartorial splendor and
made metallics essential to the thinking man's wardrobe.

III.

The social revolution...cannot draw its poetry from the past, but only from the future.
 —Karl Marx, *The Eighteenth Brumaire*

Space is the place.
 —Sun Ra

The Heavens intrigue. Always have. Ancient Egyptian court astronomers clocked/charted starry goings on to guess the future, or try to. Even back then, some understood space held the future and the future held answers.

Homegrown high priest, Midwest magician
(born, after all, in the "Magic City")
Sonny/Le Sony'r Ra/Sun Ra was our closest star.

Sun, a blinding source of energy in a constant state of explosive activity.

Sun Ra, like his planetary namesake, spun off furious amounts of heat and light.

see THMEI
a rethink tank
a cosmic clinic for the metaphysical tune-up
a private hive
a puzzle palace
a musicalmathmaticalphilosophical incubator
a black power generator sho 'nuf.

Sun split atoms, Sun Ra split assumptions.

Same difference.

IV.

...we must first redefine ourselves...We shall have to struggle for the right to create our own terms through which to define ourselves and our relationship to the society, and to have these terms recognized. This is the first necessity of a free people, and the first right that any oppressor must suspend.
 —Stokely Carmichael & Charles V. Hamilton, *Black Power: The Politics of Liberation in America*

Saturn/Chronos

 cronos=Time

Sun Ra was mystic royalty
a colossus broadcasting hybrid epiphanies,
an LP for all time, spun at an r.p.m. too fierce to follow.

Sun Ra set his best flaming foot forward, and lit (up) the way.

Bespangled student of the Universe,
he
sifted through the Testaments,

pulled our tongue out and scrutinized its roots,
penned a sexy lexicon for Nu beings and wanna beings.

Always on the edge,
Ra bungee jumped into infinity, mad music his aural vapor trail,
skywriting melodies from the other other side.

V.

> There are in every part of the world men who search.
> I am not a prisoner of history. I should not seek there for the meaning of my
> destiny.
> I should constantly remind myself that the real leap consists in introducing
> invention into existence.
> In the world through which I travel, I am endlessly creating myself.
> I am a part of Being to the degree that I go
> beyond it...
> —Frantz Fanon, *Black Skin, White Masks*

Sun Ra/New Music.
Sun Ra knew
Music
is sound
is waves
amass
can move.

Music can move you
Music is a tool.
Music is a tool to re-tool.

Sun Ra knew.
Sun Ra knew that.
Sun Ra knew that if, as they say, hearing is the last sense to leave us,
then perhaps it is time to listen
up

over and out.

5th JACK show LOUNGE

3340 West Jackson Blvd.

FEATURING LIVE ENTERTAINMENT NITELY
Presenting Thurs.—Fri.—Sat.—Sun.

THE SUN RA ARKESTRA
Chicago's Greatest Band

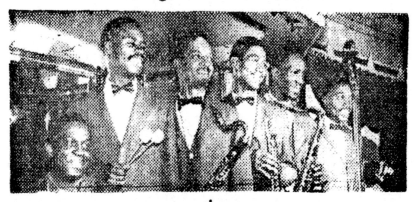

plus
RONNIE GRAHM
Nation's No. 1 Song Stylist
OPENING JUNE 30th TOMMY "MADMAN" JONES

JAM SESSION,
MONDAY AND WEDNESDAY

the Westside's Newest and Finest Show Lounge

The Early Arkestra: In the Clubs and on Film

BY ROBERT L. CAMPBELL

Sun Ra certainly kept a low profile during his early Chicago years. His first club engagement as a leader to be advertised in the Chicago *Defender* opened in December 1954. By that time he had been in town for nearly nine years, and had been rehearsing experimental ensembles for close to five. Two years previously, he had officially changed his name; in 1953, he had supplied aggressively modern arrangements for record dates by Joe Williams, Jo Jo Adams, and Red Saunders; over the past few months he had written avant-garde songs like "Bop Is a Spaceship Lullaby" and "Chicago USA" for a vocal group called the Nu Sounds. Yet his main source of income was anonymous toil in the perpetual trios that accompanied the strippers of Calumet City.

Duke Slater, the proprietor of a new lounge in the Vincennes Hotel, at 601 East 36th Street, aimed to draw attention with a Sunday matinee featuring a jazz quartet. Alton Abraham persuaded Slater to hire a combo consisting of Sunny's regular rehearsal partners: Swing Lee O'Neil, tenor sax; Earl Demus, bass; and Robert Barry, drums. The group was first advertised in the *Defender* on December 11, 1954. Interestingly, O'Neil (whose son Arthur would serve as a drummer in the Arkestra during the 1980s) was identified as the leader for the first two weeks. Abraham must have intervened, because starting on December 25 all four musicians were named in the ads and Le Sony'r Ra (to use his full official name) was designated as the leader. Yet the same issue of the *Defender* carried a genre photo of O'Neil horsing around with the club owner and two female patrons. It was indicative of the obstacles Sun Ra would face in getting publicity during the early Arkestral years.

The Vincennes Lounge gig ran out after 6 weeks (the last ad ran on January 15, 1955). Ra's quartet was replaced by an R&B combo led by saxophonist Red Simms; Demus stayed on for a while as Simms' bassist. For the rest of the year, either Simms or guitarist Lefty Bates would hold down the Sunday matinee spot at the Vincennes.

The end of the engagement meant more long hours in Calumet City, but Sunny probably didn't miss it. None of the Vincennes Lounge bands would be bigger than four pieces, and Sunny's goal all along was to write for a bigger ensemble. In early July, Abraham helped him find a gig at another new club called Shep's Playhouse. Sunny got a 5-week contract, probably for four or five pieces, taking over from a group led by bassist Eldee Young. (According to Musicians Union Local 208, the contract was signed "Herman Blount"—it would be a while before Sunny disowned his former name.) Further details are unavailable, because Shep's bought no newspaper ads.

August 1955 meant another return to the salt mines, but Sunny's rehearsal group was growing. Swing Lee O'Neil had been replaced on tenor sax by one of the top young "modernists" in Chicago, John Gilmore. Baritone and alto saxophonist Pat Patrick, who had been in Sunny's very first experimental trio, returned from a sojourn in Florida. Dave Young (trumpet) and Julian Priester (trombone) formed the brass section. Richard Evans became the regular bassist, and Jim Herndon added his tympani and "timbali" to Robert Barry's trap drums. Other musicians drifted in and out, including tenor saxophonist Johnny Thompson and (according to some sources) an out-of-towner on sabbatical named Sonny Rollins. In early October, Priester

copyrighted two scores that he had written for the band and Evans copyrighted one of his own.

As can be seen in two surviving photos, the entire octet or nonet played a series of one-nighters at the Parkway Ballroom during the fall. Sunny also landed a gig at the Grand Terrace. This venerable establishment, at 317 East 35th, had been one of Chicago's top entertainment venues back in the 1930s, when Earl Hines' big band was often in residency. By the 1950s, the center of the South Side entertainment district had shifted down to 63rd Street, and the Club DeLisa and Herman Roberts' new show lounge were eating the Terrace's lunch. However, the owners tried to revive the club in three waves during 1955, 1956, and 1957—each weaker than the last. On October 1, 1955, when they were still trying pretty hard, the Terrace announced an elaborate new show featuring blues singer Harold Burrage and "Sun Ra, His Electronic Piano and Band." (Sunny had recently bought a Wurlitzer electric piano, a major novelty in those days.) The first *Defender* ad even indulged in some Ra-ological highjinks: the impresario's name was respelled "Rhudy Krier," and one "Sonne Blount" was listed as an added attraction.

In what one suspects was direct proportion to the show's nightly take, the advertisements kept getting smaller. The last one, on November 5, took up slightly more space than a postage stamp; the show dragged on for another month, eliciting its final blurb in the *Defender* on December 3.

We don't know the exact size of the ensemble at the Terrace—probably not all 8 pieces. Still, Sunny had landed a weekend engagement on the South Side for two solid months, bringing him to the attention of more club owners. The band was next distracted by a promoter who promised a big Christmas show in Chicago, followed by a European tour. Fortunately the musicians were not left idle for too long when the scheme collapsed.

On January 5, 1956, Sun Ra and his Eight Rays of Jazz started their run at Cadillac Bob's Birdland, located at 6412 South Cottage Grove in the basement of the Pershing Hotel. Ra followed Arnett Cobb and Miles Davis into the month-old club. Cadillac Bob, whose real name was Robert Cherry, had previously operated the Toast of the Town and for a time had managed two established clubs, the Flame Lounge and Basin Street. Sunny knew the space, having played it back in the fall of 1948 when it was known as the Beige Room and he was the music director for Gene Wright and the Dukes of Swing.

Nearly half of Sunny's total publicity in the *Defender* would be generated during the next eight weeks. The ensemble now had Art Hoyle on trumpet, in place of Dave Young, while Wilburn Green's "electronic" bass had taken over from Richard Evans' standup model. The band backed such visiting attractions as Lowell Fulson, Dakota Staton, Della Reese, and Johnny "Guitar" Watson. What's more, with a steady four or five night a week gig, the band was ready to do some recording. The Sun Ra Orchestra, as it was then billed, made its studio debut on a vocal session for Seymour Schwartz's Heartbeat label, probably done in January. In February, Sun Ra copyrighted a spate of original compositions and the band began recording for the Saturn label, which he

had founded in partnership with Alton and Artis Abraham.

When the owners of the original Birdland filed a lawsuit against Cadillac Bob in February, Sun Ra got the idea to rename the joint Budland. Still, by mid-March the club was featuring a band led by Al Smith, a locally prominent bandleader whose business sense vastly exceeded his skill on the string bass. Smith remained at Budland till the first week of May, but after getting into a scrape with Local 208 for accepting less than Union scale, he gave up on club engagements to concentrate on studio work for Vee-Jay and leading occasional pickup bands at R&B shows. Most likely the Arkestra returned to Budland at this time; the Arkestra also played some Monday nights at Roberts Show Lounge (many of these were done for a social club called the Rounders) and a Ra quintet alternated sets with the Compass Players at the Argo Off-Beat Room on the North Side.

Sun Ra would retain some kind of connection with Budland for most of the next three years. But on the occasions that the club could afford to advertise in print, it adopted a fairly consistent policy of not promoting its house band, making direct references to the band's appearances frustratingly scarce. Sunny and the band played opposite Dinah Washington during her June and July 1956 engagements at Budland. From late July through mid-September, a band led by trumpeter King Kolax took over the weekends, but Sunny was definitely back in October, when Budland was formally relaunched with Little Miss Cornshucks as a headliner.

By the fall of 1956, the band had recorded two further studio sessions for Saturn, released its first singles, and made two entire LPs for Tom Wilson's Transition label. Sunny had also enlisted in a low-budget independent film project called *The Cry of Jazz*, offering several Saturn tracks to producer Ed Bland free of charge. Bland began filming the Arkestra at Budland in the summer

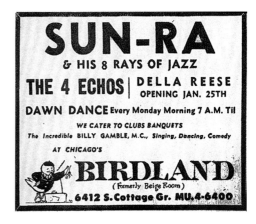

or fall of 1956; there would be additional footage from the club in 1957 and 1958, along with scenes shot at the Gate of Horn in 1958. Even though the Arkestra was not recorded live, and the musicians pretended to play Cool and Dixieland numbers as well as Ra compositions, the footage is precious, given the dearth of still photos and the complete absence of other film or video of the band. *Jazz by Sun Ra Volume 1*, on Transition, was released in February 1957, and *Super-Sonic Jazz*, on Saturn, followed in March. But any boost to the band's publicity was extremely mild.

In March, Sunny's band participated in the grand opening of the Casino Moderne, at 913 East 63rd; although the band would play occasional shows at the Moderne, it never became involved in Joe Segal's weekly jazz concerts there. By July, as Budland was enjoying a successful run by Tom Archia's organ trio with Sleepy Anderson and Charles Walton, Alton Abraham was having to buy his own blurb in the *Defender* to remind its readers that Sunny was there too. In September, when the trio had broken up and the club was going through a downturn, Abraham tried promoting Sunday concerts directly through his "Atonite" organization. The Atonite publicity is the first to refer to the band as an Arkestra; although Saturn called the band an "Arkistra" (later changed to "Arkestra") on its record releases, club owners would resist the nomenclature until Sunny was nearly ready to leave Chicago.

Pickings must have been lean for the Arkestra in late 1957 and early 1958; even rehearsal recordings of these editions of the band are scarce. In August 1957, Sunny signed a contract to play Monday and Tuesday nights at the Club DeLisa, but the deal probably called for just five pieces and the club was on its last legs; it would close its doors in early February 1958. Pat Patrick broke off to lead his own band at the New It Club in September and October 1957; John Gilmore ensconced himself at the Swingland Lounge (6249 South Cottage Grove) from December 1957 through March 1958, in a tenor-duel format with Johnny Griffin.

During this period, the band's involvement with Budland was mostly limited to playing the Monday morning breakfast dances. After the band was totally out of the club for a brief period, Cadillac Bob re-engaged Sun Ra in June. However, saxophonist Porter Kilbert, whose band was signed in August, seems to have taken over the weekend slots at the club. The Arkestra played its final engagement at Budland sometime in the spring of 1959. The club would limp along till September, then make one final try at programming live music during the early months of 1960. Cadillac Bob made a marketing error in failing promote the Arkestra as house band; the Club DeLisa ads always mentioned Red Saunders, as the publicity for Roberts Show Lounge always stressed the ensembles of Duke Groner, Porter Kilbert, Paul Bascomb, and Andrew Hill.

Around the middle of 1958, Sunny found a new home base. A gay bar called the Queen's Mansion opened in June at 6323 South Parkway. In the 1940s, this had been the address of Joe's Deluxe Club, the home of Valda Grey and "her" revue of female impersonators. The Arkestra probably began appearing on Wednesdays, the designated jazz nights, then built up to more nights at the club. According to drummer Alvin Fielder, the band played the Mansion regularly through the spring of 1959; we

have no other documentation to go on, because the Mansion was a non-Union establishment that bought a grand total of two display ads in the *Defender*.

At some point during the summer of 1958, the renowned lead trumpeter Hobart Dotson began working with the Arkestra. For an extended scene in *The Cry of Jazz*, the quintet of Ra, Dotson, John Gilmore, bassist Ronnie Boykins, and drummer William "Bugs" Cochran was filmed playing along to a 1956 recording of Ra's "Blues at Midnight." The movie was finished by the end of August, when a daily *Defender* item announced that it would be released in October. (The date would slip several months, probably for financial reasons.) By the beginning of 1959, Ra had built up a thick band book, to which Dotson was contributing pieces of his own, and Saturn had enough money to record an LP. The Arkestra went into the studio on March 6, recording the entire *Jazz in Silhouette* LP, along with *Sound Sun Pleasure!!* (which was held for release until 1970), and a long rendition of "Interstellar Low Ways" that eventually appeared on a third Saturn album.

Jazz in Silhouette, the second Saturn LP, was released in June 1959. Now considered a classic, it got one tiny blurb in the daily *Defender* for June 9, and not one solitary review in the jazz press. No sooner was it out than musicians began to peel away from the Arkestra. Bluesman B. B. King came through Roberts Show Lounge that same month and offered Hobart Dotson a place in his band. Singer Hattie Randolph left the music scene and moved to Canada. James Spaulding found his saxophone and flute in steady demand at recording sessions for Chess and Vee-Jay; by the end of the year he was appearing in North Side clubs as a leader. Baritone saxophonist Charles Davis moved to New York City. Pat Patrick was getting restless again; in June he landed a two-week gig at Gerri's Palm Tavern, and in October he joined a band

led by drummer Marshall Thompson that played Thursday nights at the New C&C Lounge (6513 Cottage Grove). In December, as Thompson's gig wound down, Patrick joined James Moody's sextet and took off for New York himself.

The Cry of Jazz did a little better publicity-wise. Many independent record labels had come and gone in Chicago, while an independent film made entirely on the South Side was something new. The movie opened on April 2, 1959 for a one-week engagement at an auditorium, followed by a handful of showings over the next few months. But such coverage as the film got was centered on Ed Bland's racial theories, rather than the music to be heard on the soundtrack.

At the beginning of 1960, Sunny's regular personnel had dwindled to John Gilmore, alto saxophonist and flutist Marshall Allen, and Ronnie Boykins. Trumpeter Lucious Randolph and trombonist Nate Pryor were available on occasion, as were drummers Robert Barry and Bugs Cochran. Ra began to rebuild by hiring multi-instrumentalist Phil Cohran, who played cornet, violin-uke, and Frankiphone (an amplified thumb piano), and a brilliant drummer named Jon L. Hardy. In January 1960, Ra was working a couple of nights a week in the Del Morocco Lounge (5114 Prairie Avenue), a neighborhood joint that had seen much better days (the address had once housed Ada's Chicken Shack, a legendary jazz and blues venue during the early 1950s). Meanwhile, John Gilmore was the nominal leader for another Ra trio or quartet at the Kitty Kat Club (611 East 63rd Street). Gilmore's tenor saxophone must have seemed out of place at the Kitty Kat, a gay bar that for years had featured the town's top piano trios: Ahmad Jamal, John Young, Andrew Hill, and King Fleming. When Ra and Gilmore came in the club was temporarily down on its luck and not buying ads in the Defender. In two weeks, Sunny was replaced by John Young; the club's fortunes would revive when the film of A Raisin in the Sun was released and the Kitty Kat could boast that some scenes had been shot there. After the Del Morocco gig ended in February, John Gilmore was briefly sighted in Baby Face Willette's organ trio at a short-lived establishment called the Hickory Pit (419 West 63rd).

Just what ended this period of scuffling is unclear, but several important things happened. Ra temporarily added Gene Easton's alto sax and Ronald Wilson's baritone to his basic lineup and recorded a concert at Majestic Hall. Located at 1316 East 47th Street in the Kenwood district, the hall was not one of the band's typical venues; it was occasionally booked by African American social clubs, showing up in Defender roundup of spring events on April 30, 1960. Alton and Artis Abraham came up with the money for another studio session, which took place around June 17. The all-day marathon produced at least 22 released tracks, including such classics as "Tiny Pyramids," "Lights on a Satellite," "Somewhere in Space," and "Rocket Number Nine Take Off for the Planet Venus." Two Saturn singles were promptly released; the rest of the material showed up on five different LPs between 1965 and 1970. And the Arkestra found a new home at the Wonder Inn.

A small club located at 7519 Cottage Grove, the Inn had opened in January 1959. Initially there was no live music, just an occasional DJ night. By the fall of that year, the club was featuring guitarist Danny Overbea and the Northern Jazz Quintet, but

it would remain a non-Union establishment. It bought newspaper ads very sporadically. All that can be said is that sometime between early March and July of 1960, Sunny and the Arkestra started playing at the Inn. On July 30, there was a special Saturday night appearance by the Arkestra; one suspects that Alton Abraham paid for the *Defender* ad. Otherwise, as we learn from an August 6 ad, Sunny was presiding over a Wednesday night jam session. The Wonder Inn's advertising budget was now permanently exhausted, so we can merely infer that at some point during the fall, the Arkestra became the club's main weekend attraction, with Jack DeJohnette (piano and drums) and Scotty Holt (bass) as the intermission act. A live set from the Inn has been preserved, and a number of tracks from the period that were released on Saturn (such as "We Travel the Spaceways," which ends with a mechanical "robot" being released into the audience) appear to have been recorded there as well. During the fall, Sunny also copyrighted a series of "space chants" that are known to have been featured at the Inn.

The Wonder Inn run continued into 1961. Eventually, however, the club's finances gave out completely—the Arkestra sometimes had to play in the dark after the electricity had been cut off. Sunny got a break in May, when a new, ambitious West Side club called 5thJack brought the Arkestra in for five weeks. Located at 3340 West Jackson, the club had opened just before Christmas 1960. It booked artists for a month or longer and advertised them faithfully in the *Defender*. Before the Arkestra, the club had featured combos led by bar-walking tenor saxophonist John Tinsey and bassist Betty Dupree. 5thJack billed the group as "The Sun Ra Arkestra" and became the only club during Ra's entire Chicago period to run a band photo in its ads (the photo had been taken at the Wonder Inn). It was on a night at 5thJack that the Arkestra mesmerized everyone in the club

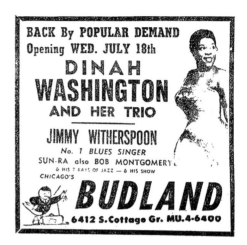

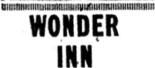

with a performance of "Interplanetary Music." At the end of June, another bar-walking bandleader, Tommy "Madman" Jones, moved into 5thJack and the Arkestra took up at the Pershing Lounge. Located on the ground floor of the Pershing Hotel (Budland was in the basement), the Lounge had been a fairly prominent venue during the 1950s, reaching its apogee in January 1958 when Ahmad Jamal recorded a hit album there. Since then the Lounge had gone through several changes of ownership and had been dark for extended periods. It could no longer afford Ahmad Jamal's fee (he was the featured attraction at his own restaurant in 1961); when the Arkestra played there the Pershing couldn't even afford to advertise in the *Defender*.

The first half of 1961 saw little recording activity. Plans for a Saturn LP release of some of the 1960 material ground along slowly (in the end, nothing would happen on the LP front till 1965); the Arkestra laid down a couple of wild studio tracks behind eccentric blues singer Yochanan, a Ra acolyte who claimed to be "The Man from the Sun;" and four tracks were recorded in an empty Pershing Lounge.

As the Arkestra's month at the Pershing drew to an end, it wasn't clear where the band might land a decent booking in Chicago, and Sun Ra had become impatient with the chronic lack of publicity. When he was offered a gig at El Morocco in Montréal, to start on July 31, Sunny jumped at it. The gig fell through, making for an eventful two-month stay in Québec, after which the core of the Arkestra migrated to New York. The Arkestra would get even less publicity there...but that story has been told elsewhere.

Acknowledgments: There would be far less to report here without the generous help, over the years, of Chris Trent, Robert Pruter, Jerry Gordon, John Szwed, John Corbett, Terri Kapsalis, Anthony Elms, Victor Simoneau-Helwani, Lenni Bukowski, Pete Gianakapoulos, Glenn Jones, Freddie Patterson, Brad Markus, Armin Büttner, Art Hoyle, Lucious Randolph, Hattie Randolph, Nate Pryor, Phil Cohran, Alvin Fielder, Bill Fielder, E. J. Turner, Ricky Murray, Marshall Allen, the late John Gilmore, the late Tommy Hunter, and the late Otto Flückiger.

SUN RA

and the Intergalactic Research Arkestra

OCTOBRE MAISON DES SPORTS VILLEURBANNE
)CATION THEATRE DE LA CITE TEL. 84.70.74

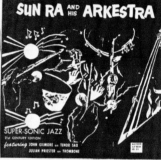

When Angels Speak of Love, they speak of higher minded beingness. Ecstatic sound vibrations interwoven by the mastery of SUN RA and his Arkestra into a Cosmic tapestry of warmth, beauty and illumination. Sound that calms the nervous system so that you can REALLY listen. Color that "blues your aura" so that you are in harmonious attunation with yourself. An otherness of existence. A beingness of

They speak of the freshness of not being possessed, as is the condition of earth-love.

When Angels Speak of Love, they speak of the accomplishment of evolving to a higher plane and reveling there with other Cospatriots—the strength and beauty of an association with bip
and spirit that
earthly pursuits

When Angel
that is beyond
of Tomorrow's
Ra, an Angel who has come back to show us!

ATLANTIS
MAGIC CITY
SPACE IS THE PLACE
ASTRO BLACK
ART FORMS OF DIMENSIONS TOMORROW
DISCIPLINE 27 II
NATURES GOD
MONORAILS AND SATELLITES VOL I
DREAMS COME TRUE
HOLIDAY FOR SOUL DANCE
NIDHAMU
A TONAL VIEW OF TIMES TOMORROW
UNIVERSE IN BLUE
MY BROTHER THE WIND VOL I
COSMIC TONES FOR MENTAL THERAPY
FATE IN A PLEASANT MOOD

"THE DEAD PAST"

The civilizations of the past have been used as the foundation of the civilization of today. Because of this, the world keeps looking toward the past for guidance. Too many people are following the past. In this new space age, this is dangerous. The past is DEAD and those who are following the past are doomed to die and be like the past. It is no accident that those who die are said to have passed since those who have PASSED are PAST.

ALL CASSETTES/ALBUMS/COMPACT DISCS MAY NOT BE IN STOCK WHEN YOUR ORDER REACHES US. PLEASE MAKE SECOND AND THIRD CHOICES. WE SHIP FROM AVAILABLE STOCK ONLY. IF ITEMS YOU ORDER ARE NOT IN STOCK ON CD OR LP, WE WILL SEND YOU CASSETTES. PLEASE ALLOW TWO TO FOUR WEEKS FOR DELIVERY.

AND OTHERS, WRITE:

EL SATURN RESEARCH P.O. Box 7124 Chicago, Illinois 60680

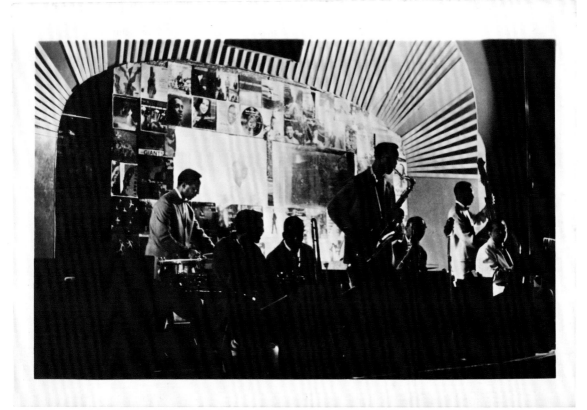

Arkestra publicity photo, c. 1956. Courtesy Chicago Jazz Archive, Special Collections Research Center, University of Chicago Library.

Sun Ra's Chicago Music: El Is a Sound of Joy

BY KEVIN WHITEHEAD

Back in the late 1990s, in Amsterdam, there lived an American bass guitarist and composer, a good and talented fellow, who like other musicians on the Dutch scene was always trolling for arcane music to revive or transform. One day, he sent around an email with wondrous news: Sun Ra wasn't just the king of free-jazz bandleaders and electronic keyboardists; before all that he'd made these records in Chicago in the '50s that were actually quite melodic and beautiful—and these amazing discoveries would be the inspiration for his own next (and successful) project. What made this missive especially odd was that even as our friend tripped over early Ra, for years already some fellow A'dam musicians had been playing that very music on regular gigs with trombonist Joost Buis's Astronotes, a band initially devoted to Sun Ra's Chicago compositions almost exclusively.

So it goes with the music Ra made in Chicago from early 1956 until he and his band departed for Montreal and then New York in 1961. Depending on who's talking, his Chicago stuff is well-known or all but unknown. To some it's peripheral, a sideshow: interesting, but nothing to compare to the sonic power and intergalactic spectacle (or Roddenberry kitsch) of Ra's Arkestra, the big band that finally gained some measure of acclaim by the 1980s, long after Sunny and company had landed in Philadelphia.

To others of us, the Chicago years are the essential first stage of the rocket propelling Ra to the heavens—this bandleader who'd reveal himself to be very fond of space travel, if only in his dreams. (He was big on dreams, where you really break free of earthly limitations.) First stage of the rocket: before you reach outer space you have to pass through an increasingly rarefied atmosphere.

To be fair, reading my friend's email back when, I knew very well where he was coming from: like many Ra folk I too had discovered his music backwards, starting with the mature Arkestra, with its trademark balance of screech and order, freedom and discipline. That was in the mid-1970s, via Impulse's Saturn reissue series. I'd already digested '60s New York blast-offs like *The Magic City* and *Atlantis* when I got around to such Chicago treasures as *Angels and Demons at Play* and *Jazz in Silhouette.* Working back to those earlier recordings only intensifies one's perception of their delicacy and beauty, their understated quality far from the revivalist fervor of the later Arkestra.

That said, in Chicago Sun Ra was already doing many of the things that would attract attention to him later. The band had begun chanting space jingles like "Rocket #9" and "Interplanetary Music," and their leader was already deploying electric keyboards (Wurlitzer piano in particular) and unusual percussion (chiefly tympani). They also engaged in a certain kind of droll pageantry whose intentions might not be clear—wearing colorful costumes, and releasing toy robots into the audience.

Ra had already hit on one musical trademark, the habit of voicing saxophones upside down, with notes bunched together at the low end of a chord and spaced wide apart at the top, instead of the conventional vice versa. That was consistent with his stump-the-soloist chord voicings on piano—the right notes obscured by some 'wrong'

order—and timbral blends that cut across instrumental sections, alchemical amalgams of unusual color. He'd been composing weirdly difficult music for years: Coleman Hawkins famously said that Ra had written the only chart ever put before him he couldn't play, an arrangement of "I'll Remember April."

Chicago afforded Sun Ra venues a-plenty and superior musicians who might be slightly predisposed to a sheltered existence under Sunny's awning. Chicago then as now was jazz's second city, despite its rich legacy as meeting ground for northern industriousness and blues-soaked southern African American talent. Long before Sunny settled in Chicago in 1946, the jazz capital had shifted to New York, and Chicago was home to those who for myriad reasons (contentment, family, lack of wanderlust, self-doubt) elected not to subject themselves to the New York pressure cooker. Chicagoans like a friendly and even not-so-friendly bandstand battle, but New Yorkers were more competitive, and, as Hawkins once observed (speaking of Cannonball Adderley), new arrivals who sounded a little funny at first quickly adapted to New York style. Chicago, less in the spotlight, and exerting less pressure to conform, may've been a better town in which to gestate a maverick musical cosmology, and find some quirky helpers.

John Szwed in his Sun Ra biography *Space Is the Place* avers that the abundance of Egyptian imagery and artifacts in Chicago fueled the bandleader's mythic perspective. Someone as fond of cosmic or religious metaphors as Sun Ra may also have been impressed by a city where a ride on the train system (called the El for elevated though it's partly a subway) might hurtle one through open space above the earth one minute and then into a subterranean netherworld the next—the realms of the angel and the demon in rapid succession. He loved the city enough to pen an affectionate city anthem, "Chicago USA," in part depicting a brisk rail ride around town. He was enough of a public transportation booster to name a tune "El Is a Sound of Joy," in that great tradition of jazz train tunes going back to early jazz (Duke Ellington had cut "Choo Choo" at his first session in 1924.)

Listening to "El Is a Sound of Joy," recorded twice in October 1956 in similar versions (we refer here to the earlier, found on *Super-Sonic Jazz*), one can with little effort project programmatic intent onto its changing musical landscape: how daydreaming on an el platform (gentle piano intro, soft meditation for saxophones) may be interrupted by the approaching rumble of the train (a rocking, increasingly insistent bari sax riff), and how once on board, the motion can turn your thoughts with anticipation to your destination (saxophone pastels with just a hint of train-whistle in the mix; eruptive arpeggios from piano suggesting a straphanger trying to keep balance on the curves), before the rhythm of the wheels catches your attention again. Then you're downtown (which is all street-corner handclaps, strutting piano, and animated dialogue with Pat Patrick's preaching alto). Like any train or rocket or typewriter tune, it's a reminder that the technology of one's time helps shape the music one way or another. "El" paints a picture of the urban environment the way 1965's spare and randomized "Outer Nothingness" depicts the void.

Individual as it is, it's not like Ra's music floated down from the sky like a candy wrapper dropped between elevated train cars. The peppy "Swing a Little Taste" from 1956 could pass for Shorty Rogers cool (the chart, if not the solos). There are times on "El" and other 50s recordings where Sun Ra's dark wind voicings recall the almost-but-not-quite-bebop composer Tadd Dameron; in that light take note of a rarely cited but remarkable Dameron song from 1949, "Heaven's Doors Are Open Wide," whose lush dissonant horn voicings, an impassive vocal by Kan Penton and a lyric preoccupied with heaven, angels, space, dreaming and personal choice make it a sort of Sun Ra ready-made. (It's from the 21 April Dameron nonet session with Miles Davis on trumpet.)

Heaven's doors are open wide
Haven't you heard?
There's love inside.
Angels cannot be denied
Give me your hand
I'll be your guide.

We'll go sailing into space
Won't that please you?
Love and beauty will erase clouds around you.

You've been living in a dream
Open your eyes
And realize
Some dreams really do come true.
So much depends
On what you do.

Eerily as this anticipates Ra's interrogatory, invitational and interplanetary modes, one suspects he was unaware of the tune, if only because he didn't record it himself, given his weakness for titles like "Third Heaven" and "Outer Heavens," and for covering oneiric tunes like "Day Dream" and "I Dream too Much."

Sun Ra's compositional voice really emerged in the 1950s, inseparable from his against-the-grain arranging. His uncanny ear guided both, mutually reinforcing the total effect of a piece, every aspect of its sound designed, and executed with clarity and discipline (no matter how much the close-interval saxophone sonorities he loved came to be associated with 'freedom'). Like Duke he'd give low horns the high notes and vice versa, to set up clashing overtone patterns that illuminated his mournful/majestic melodies with oddly tinted sidelights. He loved contrapuntal riffs and rhythms, revolving like planets in a solar system.

Sun Ra took evident pleasure in arranging standards and recent pop songs, back when he and his musicians worked dozens of show, club and bar gigs in and around Chicago, calling for a wide variety of material, and sometimes for playing familiar melodies, no matter how radically recast. Hear the remarkable *Holiday for Soul Dance*, a set of standards culled from a marathon 1960 session whose results were spread out over four LPs. It's a hardcore swinger—cornetist Phil Cohran's "Dorothy's Dance"

could be one of Neal Hefti's Basie charts (and there's another Ellington echo, Ricky Murray's stentorian-but-right baritone on "Early Autumn"). Ra recasts David Rose's hyper-pizzicato "Holiday for Strings"—the very emblem of vapid upbeat supermarket music—into an unhurried Erroll Garneresque jaunt for piano, and Marshall Allen's slithery alto.

For complexity that welds arranging and (re)composing together, the topper here is 1945's "Day by Day," the Sammy Cahn-Axel Stordahl-Paul Weston ballad with an odd ABAC form. The four-horn septet swings the A theme, and barely glances at the melodies of B and C; Ra expands the latter with a four-bar holding action, stretching the tune to 36 bars. But before you even get to the melody there's a spinning-satellites intro where tenor, trombone and alto (soon joined by piano, and trumpet, and Afro-Cuban percussion) circle each other in interlocking motion. The A melody statement itself divides the horns into call-and-response pairs. So the tune goes: recombinant throughout, resources maximized.

Circa 1960, arranger/composers like Ra or Charles Mingus implied orchestral strength by deploying members of their smaller ensembles in multiple roles like actors in a small troupe mounting an epic. That said, "space" for Ra was more than a place; the idea of it always had practical applications. Much as he loved density later, with the full Ark blasting out chords to blanket the sonic spectrum, he respected the void, and simplicity.

His musicians could get on his wavelength, and feed his vision. The classic "Tiny Pyramids," from that same 1960 marathon, is a perfect collaboration between bassist Ronnie Boykins, who penned the earworm melody, and his boss who voiced it for melded cornet and flute, suggesting some alien instrument from someone else's culture. Nothing sounds quite like this deceptively simple strut: the off-beat rhythms are abstracted from Afro-Cuban patterns, but take on another character altogether in this context: Egyptian, Saturnian, Chicagoan.

Sun Ra was well-known among musicians in Chicago, and though he always went his own way, one can tie his interests to other local developments, then or later: Von Freeman's elastic sense of harmony, or bassist Malachi Favors' (and others') incipient interest in musical Africanisms, however little was known about actual West African (or North African) music in the US at that time. ("World music" back then mostly meant belly dance records, and Martin Denny's imagined Polynesia). Favors, of course, eventually went on to the Art Ensemble of Chicago, a band given to playing unusual percussion and dissonant horns, exploiting dense and lean textures, wearing costumes suggestive of pan-African culture, and engaging in atmospheric ritual play. There's also Chicago's reputation as a theater town, locus of floorshows with roots in early jazz and vaudeville, and experimental and improvisational theater.

In light of all those connections, we end with brief look to Sun Ra's younger colleague and fellow pianist/composer Andrew Hill (1937-2007), a musician who came up on the same scene but went a different way. Still, there are a few parallels. Hill had his own taste for nebulous piano chords, lines and pedalings. In 1955 or '6 his trio with

Malachi Favors and drummer James Slaughter waxed Hill's "Chiconga" where bubbling conga nods to the idea of African percussion (more than its actual sound).

I'd asked Hill about Sun Ra in a 2004 interview; they hadn't really traveled in the same circles, he said, but "it's a small world," putting it in planetary terms. Pat Patrick had given Hill piano and saxophone lessons at the age 13, around the same time Patrick began working with Sunny, and cut a single with Hill in the mid-'50s.

In fact Hill and Sun Ra used many of the same musicians over time (most but not all Chicagoans): saxophonists Patrick, Von Freeman and John Gilmore, french hornist Bob Northern, trombonist Julian Priester, bassists Victor Sproles, Richard Davis and Alan Silva and drummer Roger Blank among them. There are also occasional sonic convergences. Hill's hard romp "Sideways," from a 1969 New York nonet session belatedly released as *Passing Ships*, could almost be one of Ra's mid-'50s barnburners like "Future," "Medicine for a Nightmare" or "Saturn." And Hill evoked the old "Tiny Pyramids" flute-brass blend in a different faux-ethnic rhythmic context, on 1970s "Ocho Rios" with Pat Patrick on flute.

These parallels suggest not the smoking gantry of direct influence—jazz flutes and flute-brass couplings were much more prevalent in 1970 after all— and we take Hill's disavowal of influence at his word. I take these echoes more as a reminder that musical ideas don't exist in a space-like vacuum: they're in the air, down here on earth.

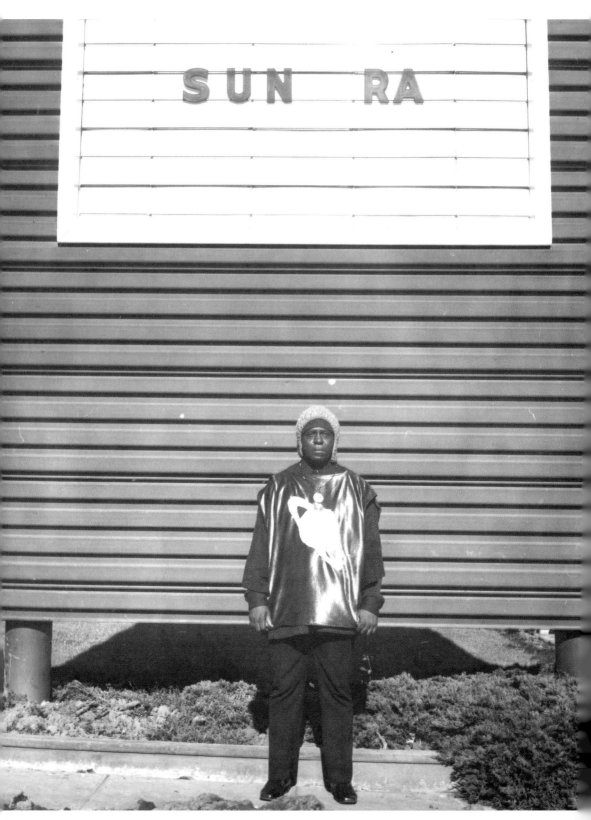

Sun Ra, circa 70s. Photograph courtesy Adam Abraham.

Right Place, Right Time, Wrong Planet (Chicago Talk Remix)

BY GRAHAM LOCK

".. he was ahead of his time, which didn't bode too well for his career."
—Von Freeman on Sun Ra

"The impossible," said Sun Ra, "is the watchword of the greater space age." So let's embrace the impossible and try to address the question, where on earth was Sun Ra coming from? Well, on earth, we know that Herman Poole Blount was born on 22nd May 1914 and grew up in Birmingham, Alabama, the "Magic City." Magic indeed, because somewhere along the way, Herman Poole Blount vanished, to be renamed, reborn and reinvented as Sun Ra, who called himself a "living myth" and claimed links with ancient Egypt and outer space, the two poles of the Astro Black Mythology that he proposed as an alternative vision of life, history and the cosmos.

When Sun Ra died in 1993, the obituaries revealed a deep unease about the Astro elements of his work. In the UK, for example, the *Independent* and the *Daily Mail* paid tribute to his music while poking fun at his philosophy, referring to his "galactic gobbledegook" and calling him a "charlatan" and a "nutcase" who had built his career on a joke. Such comments were not untypical of the reviews Sun Ra had received during his lifetime; even people who extolled the excellence of his music were often flummoxed by the Astro Black Mythology that he proposed in and through the music.

I guess it's fair to say that the chief problem jazz critics had with Sun Ra was his insistence that he came from outer space. As he put it in the 1960s: "I am not of this planet. I am another order of being. I can tell you things that you won't believe." Which, of course, he just had. (Never underestimate Ra's keen sense of humour.) The claim that he was not of this planet was not incidental to his music, but one of its foundations. For nearly four decades Ra and his Arkestra sang of roaming the galaxies and visiting other planets in songs such as 'Space Is the Place,' 'We Travel the Spaceways,' and 'Rocket Number Nine Take Off for the Planet Venus.' Space imagery figured predominantly in Sun Ra's dress, onstage and off—there's even one photo of him wearing a model of the solar system on his head (sadly, it's not to scale)—and space imagery figured too in the artwork for his LP sleeves. Many of those LPs he released on his own label, which he named Saturn, in honour of what he said was his "home planet."[1] And, to borrow Anthony Elms' astute distinction, while we can't be sure that Sun Ra truly believed all of this, there is absolutely no doubt that he *meant* it. Band members have confirmed that he behaved and spoke no differently offstage than on, and this remained the case for at least the last 40 years of his life.

So was Sun Ra insane, as the *Independent* claimed? (And as Ra's own penchant for wordplay might suggest, given the unfortunate fact that SATURN is an anagram of RA NUTS!) Well, no. As James Baldwin pointed out, when James Lincoln Collier labelled Charlie Parker a "sociopath," such language, such imputations of madness, speak only of how Europe sees the world; and there is a long and alarming history of Western psychiatry diagnosing cultural difference as madness. For instance, in 1851 an American doctor, Samuel A. Cartwright, even asserted that a slave's desire to escape from slavery was a form of mental illness, for which he advocated whipping as both

a cure *and* a preventative measure! What I want to argue is that Sun Ra's "galactic gobbledegook" becomes more readily explicable when viewed in the context of African American cultural tradition. Indeed, call it the "celestial road," as Ra did in 1979, or call it the "heavenly way," as DuBois did in 1903, but African Americans were travelling down it long before Herman Poole Blount arrived on earth.

In his 1912 novel, *The Autobiography of an Ex-Coloured Man*, James Weldon Johnson describes a Southern camp meeting at which a travelling preacher called John Brown proclaims to the assembled company that he will take them on a "heavenly march." As the congregation stomp their feet and sing, Brown outlines their progress, halting occasionally to describe sun, moon and stars in turn, as he leads them "along the milky way to the gates of heaven." Such sermons could be heard in Southern Baptist churches throughout the late 19th and early 20th centuries, although at some point the heavenly march was replaced by the gospel train. In 1927, for example, the popular black preacher Rev. A. W. Nix recorded his striking sermon, 'The White Flyer to Heaven,' in which he exhorts his congregation to accompany him on a special gospel train that will carry them through the First heaven, the Heaven of Clouds, and into outer space:

> Higher and higher! Higher and higher!
> We'll pass on to the Second Heaven
> The starry-decked Heaven
> And view the flying stars and dashing meteors
> And then pass on by Mars and Mercury,
> And Jupiter and Venus, and Saturn and Uranus,
> And Neptune, with her four glittering moons!

Turn, some six decades later, to the last track on Sun Ra's *Live in London 1990* CD and you will hear him exhort *his* congregation of concert-goers to take a similar trip and "travel the spaceways" with him to Venus, Jupiter, Neptune and, as he slyly points out, "we're goin' to Pluto too."

What makes this resemblance especially intriguing is that Rev. Nix, like Ra, was a native of Birmingham, Alabama, which raises the possibility that he may have preached this very sermon at the Tabernacle Baptist Church that the young Herman Poole Blount used to attend with his grandmother. But whether or not he heard the Rev. Nix, either in person or, as is perhaps more likely, on record, Sun Ra's space trip at his London concert (and such space trips were a regular feature of Arkestra performances) was clearly based on the heavenly journey of the Baptist sermon tradition.

There's more. In London, Ra's space trip was presented in the guise of a medley of chants (one per planet), and these space chants constitute a distinct sub-genre within his oeuvre. Brief, repetitive and antiphonal, such chants are comparable in form to the 19th century African American slave spirituals, whose themes and imagery they constantly echo. At many concerts, Sun Ra specifically drew attention to the similarity by directly quoting from or alluding to various spirituals during the performance of the space chants. Spirituals that he quoted frequently include 'All God's Chillun Got Wings,' 'No Hiding Place,' 'Sometimes I Feel like a Motherless Child,' 'Swing Low,

Sweet Chariot' and 'This World Is Not My Home.' Many of these spirituals fit easily into Ra's own cosmology: for example, 'This World Is Not My Home' accords with his claim to be "not of this planet," while 'Swing Low, Sweet Chariot' echoes his various chants about spaceships, such as "U—U—UFO, take me where I want to go." 'All God's Chillun Got Wings' may even have inspired some of the Arkestra's onstage garb, their twinkling caps and shiny robes echoing the lines "When I get to heaven, gonna put on my crown…gonna put on my robes" etc. ("Gonna put on my shoes" too—see Glenn Ligon for the importance of Sun Ra's space boots.)

More generally, the spirituals are important as a precedent: they propose a utopian site, a heavenly space, through which African Americans can move freely and feel at home—as 'All God's Chillun' puts it, "I'm gonna fly all over God's heaven." The difference is that the spirituals represent this heaven in terms of a Christian mythology, as the promise of an after-life, whereas Sun Ra's space chants declare that, by embracing the Space Age, African Americans can enjoy the freedom of the heavens in this life.

Consider too the manner in which the Arkestra performed the space chants. Band members would leave their seats and come to the front of the stage, where, clapping and chanting, they would circle in a counter clockwise direction, just as happened in the ring shout, the central ceremony of African American slave worship and the original arena in which the spirituals were sung. Lawrence Levine, in his book *Black Culture and Black Consciousness*, explains that the ring shout frequently took on a mythic dimension:

The shout often became a medium through which the ecstatic dancers were transformed into actual participants in historic actions: Joshua's army marching around the walls of Jericho, the children of Israel following Moses out of Egypt.

Or, we might add, some 150 years later, Sun Ra and his Arkestra, in their starry crowns and glittering robes, walking all over the secular heaven of the solar system, proclaiming in the *present* tense, "We travel the spaceways, from planet to planet."

I guess what I'm trying to do here is locate Sun Ra in an African American tradition of what I'll call *transformed space*, which took early form in the ring shout and later shape in sermons like 'The White Flyer', in which, as Paul Oliver has noted, Rev. Nix "made the vision real by projecting himself into the scene and carrying the congregation with him on the heavenly train." Making the vision real was a central impulse in Sun Ra's performances too, and if his vision has been dubbed 'Afro Futurist', the means he used to actualise it were steeped in 19th century black cultural traditions—the better to emphasise, perhaps, that his outer space utopia was offered as an alternative to the mythic space usually invoked by those means, i.e. the Christian heaven.

That proposal, I think, was central to Sun Ra's purpose. His antipathy to the Black Church is well documented in interviews and pamphlets, and one of his chief complaints against the Church was its refusal, so he said, to embrace the science and technology that promised a better future. As he told writer Mark Sinker, referring to the 1950s, "I was talking about computers, I was talking about spaceships, I was talking

about flying into outer space…A black minister told me, 'Hey, this ain't in the Bible.' I said, 'I don't care what it says in the Bible, that's what's going to happen.'" [2] Or, as Ra told the audience at New York's Soundscape in 1979, "You've outlived the Bible, which was your scenario. You're in a science fiction film now."

Sun Ra's hostility to the Black Church may also provide a key to one of the more bizarre episodes in even his career: his account of being abducted by aliens, an event that reportedly took place in the mid-1930s, well before the first officially documented claim of alien contact in 1952. But then again, just as African Americans were travelling the spaceways back in the 19th century, so too were they being abducted by aliens.

My evidence for this is the Afro-Baptist conversion testimony, a sub-genre of African American autobiography that deals specifically with the realms of myth and mystery. These testimonies were concerned with a common form of spiritual rebirth into a new identity. Zora Neale Hurston collected a few examples in Nancy Cunard's 1934 anthology *Negro* (including an incident of divine/alien probing from 1867!), but a more comprehensive collection, originally taken from unnamed former slaves in the 1920s, was later published in the book *God Struck me Dead*. The experiences that these testimonies describe—many of which involved being abruptly transported to a strange place, identified as heaven, and encounters with beings dressed in robes, identified as angels—were an essential part of Afro-Baptist belief: such testimony would not only secure full membership of the church but was also a prerequisite for salvation.

Sun Ra's account of his abduction by aliens frequently echoes certain details of the conversion testimonies (and both echo the spirituals). For example, many of the converts describe being taken to heaven, often by flying through the air or by travelling along a very narrow path: Sun Ra's story of his initial visit to what he identified as another planet incorporates both the elements of flying *and* of travelling along a narrow route:

I did go out to space through what I thought was a giant spotlight shining on me…I had to go up there like that (*imitates a mummy*), in order to prevent any part of my body from touching the outside…So this spotlight—it seemed like a spotlight, but now I call it the energy car—it shined down on me, and my body was changed into some beams of light…and I went up at terrific speed to another dimension, another planet.

Some of the converts relate similar experiences. One reports "A light seemed to come down from heaven, and it looked like it just split me open from my head down to my feet." (This image is prefigured in a spiritual too: "On a my knees when the light pass'd by…Tho't that my soul would rise and fly.") Other converts report being "struck dead" or struck dumb by a great surge of energy that carries them to what could be called another planet, although they call it either heaven or hell. On arriving at his new planet (where he later encounters beings dressed in robes), Sun Ra recalls seeing "something like the rail—the long rail—of a railroad track comin' down out of the sky." This image recalls his LP title *Monorails and Satellites* (with its cover artwork of a piano keyboard as a kind of interstellar railway track), as well as the lines "Ain't but one train on this track/Runs to heaven and runs right back" from the spiritual 'Ev'ry Time I Feel the Spirit;' it also recalls the Biblical image of Jacob's ladder, as described

in at least one of the conversion testimonies: "I saw as it were a ladder, it was more like a pole with rungs on it let down from heaven and it reached from heaven to earth." The origin of all this imagery—the narrow path, the spotlight, the railroad track, the ladder—is, I would suggest, Matthew, chapter 7 verse 14, which Rev. Nix quotes as the text for his 'White Flyer' sermon: "Strait is the gate and narrow is the way that leadeth into life, and few there be that find it."

So did Sun Ra have a 'real' experience, similar to those of the converts, but which he described in the very different context of space travel? Or was his story part of a constructed mythology, a signifying rebirth parable based on the kind of testimonies he would have heard in his childhood? Rather than speculate on such imponderables, the point I'd like to stress is that Sun Ra's abduction story evokes what for many people was a genuinely life-changing experience, but that it revises and updates that experience in the futuristic language of science fiction, just as the space chants revise and update the cosmology of the spirituals. Whether Sun Ra's trip to another planet was physical or psychic, visionary or imaginary, its significance perhaps lies more in the way in represented it; not in Biblical terms, but as a science fiction scenario, as if to signal to African Americans that the only way to define a personal identity, to experience a form of rebirth, to be "saved" in fact, was not by following the old myths of the Christian Church and its Bible, but by embracing a future in which (as he sang in one song, based pointedly on the spiritual 'No Hiding Place'): "The space age is here to stay/Ain't no place that you can run away."

For Sun Ra, an empowering Astro Black mythology could replace a history of black enslavement and oppression, because space—as he sang in the chant that virtually became his theme tune—was the place where:

> There are no limits to the things that you can do
> There are no limits to the things that you can be
> Your thought is free
> And your life is worthwhile

And by living his myth, by willing himself reborn and renamed as a myth, he made it come true.

Bonus Track (Chicago Talk Coda)

If Sun Ra's work begins to make more "sense" when heard as a dialogue with (or as signifying on) the Afro-Baptist Church, it takes on sharper focus still the better-acquainted the listener becomes with other aspects of African American cultural history. Two brief examples. The film *Space Is the Place* opens with a scene in which Sun Ra inspects a distant planet to check its suitability for habitation by black people from Earth. The reference here is to Martin Delany, a pioneer of black nationalism, who, in 1859, led an expedition to the Niger Valley to find locations in which African Americans would be able to settle. Delany's report of that expedition was republished in 1969 under the title *The Search for a Place*: a title that *Space Is the Place*, filmed in 1972, answers directly, a point underlined by the fact that the film's title first appears onscreen immediately after Ra has approved for black settlement the planet he's been inspecting.

My second example is more tentative. The song 'Let's Go Fly a Kite' was featured sometimes in the Walt Disney tributes that became a regular part of Arkestra concerts in the late 1980s/early 1990s. It struck me as a slightly odd choice and when I saw the band perform it live in 1990, it seemed odder still, as they mimed their kite-flying while strutting across the stage with the same kind of exaggerated delight that marked their performance of Irving Berlin's 'Slumming on Park Avenue.' In that song, it was clear that the Arkestra's intention was to interpolate a racial dimension into Berlin's satirical take on class relationships; but I had no idea what they were up to on 'Let's Go Fly a Kite.' Then, just a few months ago, I think I found the answer.

In July of last year, I was looking through a copy of the *New Statesman* when I came across an article by Andrew Stephen about slavery in Washington, D.C. A highlighted extract from *The Black Codes of the District of Columbia*, published in 1848, caught my eye:

CHAPTER XCVIII
PUNISHMENT OF SLAVES FOR FLYING KITES

If any slave shall fly any kite or kites, within the limits of this corporation, on conviction of the same before the mayor, and being found unable to pay a fine, for every such offence, not exceeding two dollars...such offender may be punished by whipping at the discretion of the mayor.

I did wonder momentarily if Sun Ra would have been aware of such a prohibition, but we know he was a voracious reader and a keen student of black history, so it certainly seemed possible. Confirmation came later courtesy of Jason Guthartz and Jonathan Piper, who uncovered a reference to such a prohibition in *Time* magazine. In July 1967, *Time* ran a story about Thurgood Marshall's appearance before the Senate, prior to his appointment as an Associate Justice of the Supreme Court: during questioning, Marshall had cited the prohibition on flying kites as an example of the Black Codes. I think it's reasonable to assume that Sun Ra would either have read the *Time* report himself or at least heard about it, since Marshall's appointment and Senate appearance had been a major news story at the time, and was keenly followed by many African Americans.

In fact, the real question here is not, did Sun Ra know about this?—it's why didn't *I* know about it? Why did no-one make that link? How come we know so little about certain aspects of the past? Andrew Stephen's article, for instance, begins with his shocked discovery that a dark, mysterious cavity, too tiny for him to stand up in and located *beneath* the basement of his Washington home, had once served as living quarters for the household slaves. (Note, as with the prohibition against kite flying, the denial of *space*.) "There are other worlds," Sun Ra sang, "they have not told you of, that wish to speak to you." These other voices, other blues, other histories, are speaking to us through his music.

I can't prove that Sun Ra had the Black Codes in mind when he chose to perform 'Let's Go Fly a Kite,' but it fits with his interest in African American history and it fits too with his acute, often deadpan, sense of humour. He would surely have relished the chance to poke fun at the truly insane and petty racist bureaucracy that had

constricted black life in the 19th century—and continued to do so in the 20th, not least in his hometown of Birmingham, which in 1930 had, for example, passed an ordinance that prohibited blacks and whites from meeting together to play dominoes or checkers, I assume to protect the myth of white supremacy from the threat of a black victory at checkers! ("It's not too good to be supreme," Ra told me in 1983. Then he added with a chuckle, "But it's nice to be superior.")

So, no, it seems Sun Ra was not a charlatan or a nutcase at all; he just knew a lot more about black culture and black history than his critics did. This, I suggest, is where (on earth) he was coming from. As Ralph Ellison once remarked to *his* critics, "If you would tell me who I am, at least take the trouble to discover what I have been." Ra was fond of saying, "History is only his story. You haven't heard my story yet." That "my story" was, I think, less mystery than alternative history, a black history, to which Ra constantly alluded—onstage, on record, in person. If we still haven't heard his "my story" yet, it's because we didn't take the trouble to discover whose story he was really telling. Now that we know we were wrong, we should take Ra's advice and *face the music*. It's time to listen to his cosmos song.

1. I've written elsewhere that Saturn, which began to release singles in 1955, was one of the first artist-owned record labels. I now know this was not the case. In the 1940s and early 1950s, several jazz artists—including Duke Ellington, Mercer Ellington, Art Hodes and Lennie Tristano—either owned or co-owned their own labels. In fact, Sun Ra was not even the first jazz artist to name his label after a planet: Woody Herman had launched his Mars label in 1952. Thanks to Victor Schonfield for this information.

2. Ra's criticism of the Church's attitude to space travel may have been informed by the gospel response to the Space Race of the late 1950s, given expression in such songs as Sister Dora Alexander's warning to 'Let God's Moon Alone' (albeit that her imprecation was directed chiefly at "wicked Russia," which appeared to be winning the race). See Guido van Rijn's *The Truman and Eisenhower Blues*.

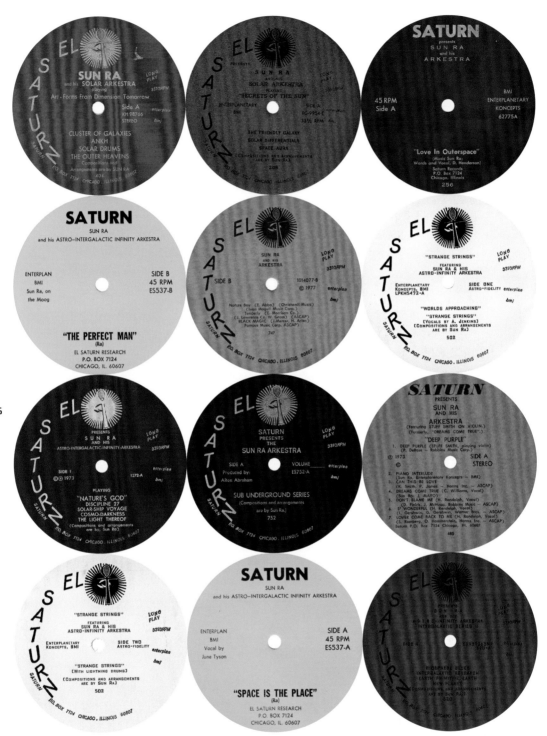

Assorted inner labels. Courtesy Chicago Jazz Archive, Special Collections Research Center, University of Chicago Library.

Obscure Past, Bright Future: Saturn Records in Silhouette

BY JOHN CORBETT

We have a little historic marker in Chicago this year [2006], an important one.
El Saturn Records is celebrating the 50th anniversary of its first release, which was
issued in 1956. It is very possible that it was issued right around this time of year,
November or December. The recordings for the 45-rpm single were made early in
the year and it is probable that it took that long to edit, master, design and press,
since it was a first production.

The El Saturn record label was chartered by Sun Ra and Alton Abraham together
with some of Abraham's friends—financial backers who had little input into the
label—in 1955 here in Chicago. In 1956 they reputedly issued a single, the first piece
of vinyl that they ever put out. It featured a song called "Saturn," composition by Sun
Ra. The especially interesting thing about Saturn's first record, however, is that it was
little more than a rumor until just recently. In Sun Ra scholarship and collecting, a
hard copy had not been located until the middle of 2006. Everybody associated with
the label, especially Alton Abraham, remembered the record having been issued, but
none of the principals had a copy, and none were found until a lone record appeared
on eBay. I personally bid a thousand dollars. I didn't get it. I should have bid more. But
I didn't have more so I bid what I could. Maybe if all of us had gotten together and each
bid a thousand dollars, we could have raised enough to buy it. Even though I wasn't
highest bidder (in fact, the record was removed from the auction before anyone hit the
reserve and seems to have been sold privately), I did get a chance to see a picture of it
on eBay, so I am convinced that it is more than a rumor.

What is fascinating about this mythical single, and what has been interesting in
the process of assembling this exhibition, is that it has made us analyze the way El
Saturn Records functioned as a business and as a producer of material artifacts. I think
many of us who have been listening to Sun Ra for a while consider his Chicago era to
have been a particularly productive period, especially in terms of record making. That's
partially true, of course. There are many LPs that Ra fans consider "Chicago" records.
But in putting the exhibition together, what became evident was that while Sun Ra was
here in Chicago, Saturn actually only released *two* LPs. True, on Saturn Records there
are probably 15 or 16 "Chicago" records that were ultimately issued, but while Ra was
living and working here the label put out two long players. Then when the Arkestra
moved to New York it seems they really needed more "product," they needed records
to support their newfound success in the Big Apple. So they went back into the vaults.
Ra had recorded an enormous amount of music while he was in Chicago. Very little
of it was catalogued or prepared for release, because when Ra left Chicago in 1961, on
a gig in Montreal that turned into a one-way ticket out of the Windy City, he hadn't
planned on leaving for good. Documents show that he was already thinking seriously
about New York, however; Abraham was lobbying hard for gigs there, and that Ra
believed that New York was where he would find an international stage, which was
his interest from the mid '50s onward. But there is also evidence that the move took
Abraham by surprise. In Montreal, a lengthy residency fell through, leaving Ra and

his small band stranded. Ra took it as a sign. They stayed there for a few months and then Ra asked the band what they would think about going to New York. A couple of them said no, but he said well that is where we are going. So they left for New York, contacted their Chicago associates and let them know they'd relocated, asked Abraham to ship their things and Western Union some cash. At that point Ra continued his relationship with Chicago via Abraham, as record producer and business manager. Alton, who had also gone up to Montreal to discuss the move with Ra, managed Ra's affairs by remote, really, until the Arkestra settled full force in Philadelphia in the late 60s. Even then, with saxophonist Danny Thompson responsible for the Philly wing of Saturn, Ra continued his association with Abraham, who remained a lifelong Chicagoan.

The very first LP was called *Super-Sonic Jazz*, and it came out early in 1957. As I mentioned, Saturn put out a series of singles. It is notoriously difficult to determine when exactly the singles came out but we know that "Saturn" came out in 1956. In the archive there is actually a recording of the Arkestra from 1956 playing at the venue Budland, a very important place in Sun Ra's history, know as Birdland, before that known as the Beige Room. There's an unreleased recording of the band live at Budland, and the end of it the concert they play "Saturn." "Saturn" is sort of Ra's theme, the band's signature song. At the end of the song, Abraham's distinctively basso profundo voice cuts through the audience applause, saying: "That's *strictly* a hit. That's our new record!" This is probably a reference to the single. In fact, the recording itself was known, as it was discovered in the tapes when Evidence was reissuing the Sun Ra singles. We didn't know what the single looked like, but we knew what it sounded like.

What is so magical about the debut version of "Saturn" is the solo of tenor saxophonist John Gilmore, who always said that playing this Sun Ra composition was precisely what convinced him to stay with the band for so long. The featured artist is Art Hoyle, on trumpet, who also takes a splendid solo. Wilburn Green, who plays electric bass, is one of the first electric basses in jazz. It's a great version of a magnificent tune. We found another, earlier, take of "Saturn," from 1954 or so, just after Wilburn joined the band, in the archives. It's the same main melody, but it doesn't have the complicated preamble, the rumbling two-tone frontispiece or the boppish A-section. It just starts with the B-section melody and swings like crazy.

Super-Sonic Jazz was Saturn's initial offering, and then came *Jazz in Silhouette*. Its cover came in several versions, the first of which was hand-silkscreened and boldly designed with an Egyptian eye image. This version is quite rare. The cover design is credited to one H.P. Corbissero, but I think H.P. is probably for Herman Poole, Ra's original name. It is a striking, crude image. They probably printed the covers in Alton's basement as they did many of their records. In terms of self-production, with this record we are witnessing the emergence of the independent record industry right here in Chicago. The self-produced first-edition of *Jazz in Silhouette*, packaged with a self-manufactured cover, was issued by Saturn in the late '50s. The second edition, which came out in the '60s, is a little bit better-known. It always struck me as an enormously strange record cover to have on a Sun Ra record, with its naked space nymphettes. There

SATURN — TUT'S
SATURN'S SPONSORS' AGREEMENT

AGREEMENT MADE THIS ___ DAY OF _____ 19__ IN THE CITY OF _____ STATE OF
_____ BETWEEN TUT RECORDS, HAVING ITS PRINCIPAL OFFICE AT
4115 S. DREXEL BLVD. IN THE CITY OF CHICAGO, STATE OF ILLINOIS AND
(MR. MRS. MISS) _____ KNOWN AS SPONSOR, FOR THE SOLE
PURPOSE OF OFFERING, AND APPLYING MONIES OR SECURITIES TO BE USED FOR
THE PRODUCTION OF ___ ~~ONE~~ RECORD ~~~~ NAMED OR NUMBERED _____ .
STREET ADDRESS OF SATURN RECORDS 4115 SO. DREXEL BLVD. _____ .
PHONE NUMBERS DR.3-4390, HY __ -27, __ _____ .
STREET ADDRESS OF SPONSOR _____ .
PHONE NUMBER _____
_____ .

I TUT RECORDS ACCEPTS THE SPONSORING OF (MR. MRS. MISS) _____ ,
 FOR THE PRODUCTION OF __ ~~ONE~~ ORDER RECORD A ~~~~ NAMED OR NUMBERED.

II TUT'S RECORDS IS TO PAY (MR. MRS. MISS) _____ , SPONSOR, A
 SUM EQUAL TO (~~ TWENTY-FIVE~~ PERCENT OF THE NET PROCEEDS RECEIVED
 BY SATURN, FROM THE SALES OF 1 RECORD ~~~~ NAMED OR NUMBERED

III ~~SATURN'S~~ TUT'S (CPA) ACCOUNTANT IS TO KEEP AN ACCURATE RECORD OF ALL SALES
 AND SALES ORDERS SUBMITTED TO SATURN, OF RECORD NAMED OR NUMBERED
 _____ , BY THE DISTRIBUTORS AND RECORD SHOPS ADOPTED AND
 ACCEPTED BY SATURN. THESE RECORDS AND REPORTS WILL BE AVAILABLE TO
 (MR. MRS. MISS) _____ , OR HIS, HER, LEGAL REPRESENTATIVE
 UPON GIVING SATURN RECORDS, IN WRITING, 7 DAYS NOTICE.

IV _____ HAVE NO AUTHORITY TO BIND THE COMPANY OR TO
 GIVE ANY WARRANTIES WITH REGARD TO THE COMPANY'S PRODUCTS OR ARTISTS,
 OR TO ADJUST ANY COMPLAINTS AGAINST SATURN RECORDS, EXCEPT WHERE
 SPECIFICALLY INSTRUCTED BY SATURN TO DO SO.

V ~~PROCEEDS ON (1) TWENTY-FIVE PERCENT FROM SATURN RECORDS, FOR SAID~~
 ~~1 RECORD FROM TO (MR. MRS. MISS)~~ _____ ~~IS TO BEGIN~~ ~~~~
 ~~AFTER COMPLETED LIST OF HAS BEEN ON SALE TO THE PUBLIC FOR AT~~
 ~~LEAST MONTH PAYMENTS ON THE (1) TWENTY-FIVE PERCENT IS TO BE MADE~~
 ~~REGULARLY TO THE SPONSOR, IS TO BE MADE ONLY ON DATES AGREED UPON~~
 ~~BY SATURN RECORDS AND SPONSOR, (QUARTERLY, BI-ANNUALLY, ANNUALLY)~~

VI THE DURATION OF THIS AGREEMENT SHALL BE AT LEASE ___ MONTHS AND SHALL
 BE TERMINATED WITHOUT THE CONSENT OF THE SPONSOR.

VII PAYMENTS TO (MR. MRS. MISS) _____ SHALL VARY ACCORDING TO
 NUMBER OF SALES. ~~MADE FROM~~ ~~A PERIOD OF~~
 ~~DAYS FROM DATE THE 1 RECORD IS ON SALE TO THE PUBLIC.~~

V ACCOUNTING OF THE ROYALTIES TO _____ SPONSOR
ARE DUE FORTY-FIVE DAYS AFTER DECEMBER 30TH
AND FORTY-FIVE DAYS AFTER JUNE 30TH.

Rough draft, sponsor's agreement, c. 1959. Courtesy Chicago Jazz Archive, Special Collections Research Center, University of Chicago Library.

are a few tracks here that have sexy, jazzy titles, but not many. Most have the Egyptian and space titles that are predominant later. Certainly the idea of naked space ladies doesn't seem so appropriate to the Arkestra's advanced musical concept, but it is a rich, playful image nevertheless. The designer's name is Evans—we don't know who that is, but it is credited on the back of the LP.

One of the nagging questions that came out of the exhibition is: Who was Claude Dangerfield? This film-noir name came up over and over. By name, he was credited with the design of only one of the records, but Dangerfield evidently designed many

Alton Abraham's notes for Saturn debut LP, 1957. Courtesy Chicago Jazz Archive, Special Collections Research Center, University of Chicago Library.

of them. In fact, the majority of the Chicago LPs had covers drawn by Dangerfield, who was a friend and colleague of some Arkestra musicians at DuSable High. What we have, then, are a large group of Saturn Records with Chicago era music, sporting covers that were designed while Sun Ra was in Chicago. All but two of them, however, were edited, assembled and issued after Ra had moved to New York. In fact, some of the records—*Sound Sun Pleasure* for instance—were designed and recorded in the '50s, assembled and produced in the '60s, and then not released until the '70s—a very strange and historically bewildering chain of events.

Abraham had been looking for a designer for Saturn. Dangerfield was an artist recommended by his musician peers, and he submitted numerous proposals and preliminary designs. It's amusing to observe that the earliest designs Dangerfield made for Saturn weren't even square, a logical prerequisite for an LP cover. The fledgling designer made a variety of sketches for record covers between 1956 and 1960, and those drawings became the foundation for subsequent designs, as they were mutated, reworked and transformed into later images. The final designs were often composites from the original sketches and previous finished designs. To further complicate matters, Saturn's '50s designs were retrofitted with new typography in subsequent decades, often identifying the ensemble with a name that was only used much later than the music it's associated with. See, for example, the 1956-58 Saturn LP *Sun Ra Visits Planet Earth* is credited to the Solar Arkestra, a title that Ra started using after he'd been in New York awhile; more disparately, consider *We Travel the Space Ways*— recorded in 1956, but credited to the Myth-Science Arkestra, a late '60s assignation.

As a result of this protracted, anachronistic, pragmatic and sometimes scattershot production methodology, the Saturn productions often assumed to be made while Ra

FEBRUARY, 1957	FEBRUARY, 1957
SUN. 17	SUN. 24
MON. 18	MON. 25
TUES. 19	TUES. 26
WED. 20	WED. 27
THUR. 21	THUR. 28 ARKISTRA PLAYS AT HINES HOSPITAL ? TO 8 PM.
FRI. 22	FRI. 1 MARCH
SAT. 23	SAT. 2

Alton Abraham's datebook listing Ra's performance at psychiatric hospital, 1957. Courtesy Chicago Jazz Archive, Special Collections Research Center, University of Chicago Library.

was in Chicago were in fact almost all produced later. Such is the case with *Cosmic Tones for Mental Therapy*. When I first interviewed Abraham in 1993, he told me about Ra's experience playing for patients at a psychiatric hospital. According to Abraham, a catatonic woman who hadn't spoken in years burst forth at the end of the performance with: "You call that music?!" Of course, I knew about the LP that commemorated this event, but I gently corrected Alton that the hospital performance must have occurred in New York, as that was where the LP was recorded. No, Abraham insisted, it happened in Chicago, and relatively early. I relented, but secretly assumed that he remembered incorrectly. Years later, I discovered a date book in the Abraham archives from 1957, with an entry: "Arkistra at Hines Hospital." (Note: an early alternate spelling of Arkestra was "Arkistra.") So he was right after all. Who designed the cover for the 1960s New York recordings that were issued on a Saturn LP under the title *Cosmic Tones for Mental Therapy*? Claude Dangerfield, circa 1958, natch. In this case, later music is coupled with a much earlier cover, a reverse situation from the usual early music and later cover design. Then again, recall Sun Ra's introduction to the film *Space is the Place*, in which he says that his first act upon establishing a black planet will be to decree "…time officially *ended*." A deep disturbance of temporal-historical relationships was perhaps what Ra was after, aided by a somewhat disorganized and on-the-fly business practice.

The Arkestra released a third LP while in Chicago, this one without a Dangerfield image. *Jazz by Sun Ra* was issued on Transition, a Boston based label with an interesting angle on releasing jazz music. Transition had a sponsorship program. It attempted to find people in the community to financially support the records, fans that would theoretically get a cut of profits made on the record. It was a bit of a pyramid scam, forgive the Egyptian reference. In fact, before the term had a negative connotation, pyramid business

arrangements were of interest to Abraham and Ra, as Saturn records show. In the Saturn archives, a beautiful set of documents shows Abraham planning a Saturn sponsorship program—he tentatively retitled it Tut's Sponsor's Program—with bold claims of the gigantic future for the label and all associated with it. Transition didn't last very long, went out of business right away. Fortunately, Abraham didn't follow suit. In a letter to the musicians' union president James Petrillo, perhaps never sent, Abraham suggested that the Arkestra's search for mind-altering atonal music needed a special support system, one funded externally, probably governmentally. They never got that support, fancy that. But they managed to keep the label and the whole Ra Arkestra enterprise up and running for nearly four decades, entirely independent.

I was always struck by the strangeness and beauty of the title *Jazz in Silhouette*, which made me reflect on how Ra and Abraham were fascinated by shadows. They were interested in the word "Shadow," for instance, as an African-American nickname. In a press release for *Super-Sonic Jazz*, they wrote: "Today is the shadow of tomorrow because coming events cast their shadow before. 'This music is alive,' it is not the shadow, it is the reality in a prevue form." They were interested in the idea that the present is the shadow of the past and the past is the shadow of the present. The silhouette, a play of positive and negative space, what is present defined by what is absent and vice versa. A mystical way of predicting the future, looking for the shadow it casts on the past, what silhouette it creates in the present. How well this resonates with Saturn's approach to record production, the notion of taking tapes from the past and projecting them into the future, allowing them to cast their long shadows, forcing time to obscure their provenance, to blur their origins, if not their originality. If Ra was a "forward thinker," he was moreover a non-linear thinker, which means, to some degree, abandoning the notion of temporal forwards and backwards and imagining the interpenetration of past, present and future. Each is the shadow of the other, making Sun Ra's living music a presentation of future reality in preview form.

Jazz in Silhouette. It's not jazz, per se. It's the outline of jazz, the futuristic relief of jazz. The germ of Matisse's jazz cut-outs, background and foreground forever locked in antiphonal communication. Jazz silhouetted: an absent space in which jazz can transform into something else. A series of Jean Arp-like cover designs, probably by Ra, are all silhouettes, suggestive of some 3-D shape forever hidden in their flat, binary black-and-whiteness. (See *Angels and Demons at Play*, the only one of them that was issued.) *Jazz in Silhouette.* I always thought: What an evocative title—I love that. I wonder where it came from? Did Abraham make it up? Or Ra? Looking through some of the collection of books from their joint library, in 2006, we came across a beautiful little clue: Trowbridge Hall, *Egypt in Silhouette* (1928: New York, MacMillan).

Note: Subsequent to this lecture, sketchy biographical information was discovered about Claude Dangerfield, who was apparently born in 1931, lived much of his life in California, where he died in 1988. Thanks to Michael Slaboch for this information.

2/16/59

A few more Saturn Records and
I'll be glad to be a dj again.
That sound is fine!
To coin a phrase — "It swings"
keep sending and I'll keep
spinning — Dick

43

Fan note, 1959. Courtesy Chicago Jazz Archive, Special Collections Research Center, University of Chicago Library.

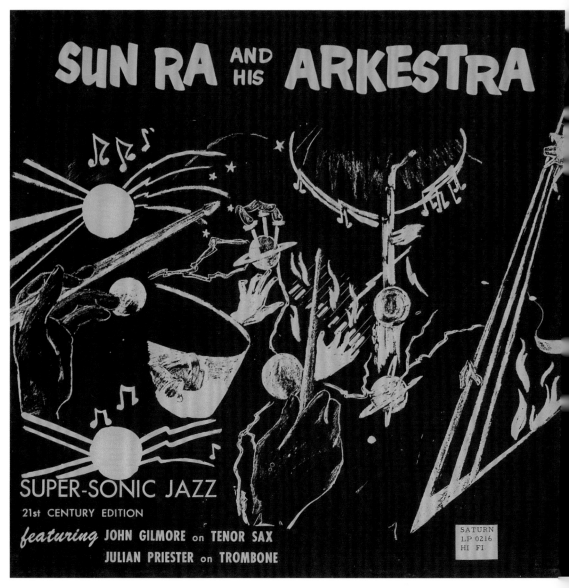

Fig. 1 Claude Dangerfield, *Super-Sonic Jazz*, album cover, 1960s. Courtesy Chicago Jazz Archive, Special Collections Research Center, University of Chicago Library.

El Saturn Records and Black Designers in Chicago

BY VICTOR MARGOLIN

When Sun Ra and his business manager Alton Abraham founded their own Chicago record label, El Saturn Records, in 1955, they were continuing a tradition of black-owned businesses that began early in the 20th century. Among the first of these businesses was Robert Abbott's *Chicago Defender*, which became the most widely circulated black newspaper in the United States following its founding in 1905. In his seminal book *Black Chicago: The Making of a Negro Ghetto, 1890–1920*, historian Allan Spear continues the story with a description of black commerce during the 1920s and 1930s, citing Anthony Overton, Jesse Binga, and other entrepreneurs as exemplars of Chicago's first black business class.[1] Since then John Johnson founded the Johnson Publishing Company in 1942, when he began to publish *Negro Digest*, and in 1954 George Johnson established Johnson Products, now one of the leading suppliers in the beauty care industry.

These entrepreneurs, like Sun Ra and Abraham, and others who followed, needed artists and designers to create their graphics just as their white counterparts did. However, until recent years commercial art or graphic design as the profession was subsequently called did not attract many African-Americans due to the perception that they would be unable to succeed because of their race. Nonetheless, black artists on Chicago's South Side developed their visual skills through various practices including sign painting, lettering, and cartooning. Sign painters and lettering men did much of the local advertising work. Their lineage stems from George Davenport, who was prominent in the early 1920s, through Frank Phillips, Mentrell Parker Sr., and others including Vernon Guider, who built a reputation designing signs and show cards for the Regal Theater as well as for churches, restaurants, and other clients.

The leading patron of black cartoonists was the *Chicago Defender*, which spawned a long line of artists including Jay Jackson, L.N. Hogatt, Leslie Rogers, Dan Day, and Chester Commodore. One of the Defender's early cartooning successes was the comic strip, "Bungleton Green," which was based on Robert Abbott's college roommate Charles 'Bung' Thornton.[2] *Defender* cartoonists could draw in a variety of styles and express a wide range of emotions. Cartooning within the black press thus spanned a range of emotions from the light-hearted humor of "Bungleton Green," to the hard hitting political messages of Jay Jackson's editorial cartoons (*Fig 2*).

An early source of information on black commercial art practices on the South Side is *Black's Blue Book* of 1923-24, a directory of African-American businesses in Bronzeville. One finds in this book an announcement for the sign painting services of Frank Davenport (*Fig. 3*); two ads by C.E.J. Fouché, who headed his own commercial art agency, C.E.J. Fouché Advertising Company; a full page advertisement for Anthony Overton's Victory Life Insurance Company drawn by Charles Dawson; and an advertisement for Dawson's own services as an illustrator, letterer, and commercial artist. Dawson is a particularly important figure in the history of African-American design in Chicago. From Brunswick, Georgia, he made his way to New York where he was the first African-American student at the Art Students' League. Following his studies there, he came to Chicago and enrolled at the School of the Art Institute, where

"A Word About These, Mr. President"

Largest Sign Shop On The South Side

BUSINESS PHONE DOUG. 9170 RESIDENCE PHONE OAKLAND 4620

H. GEO. DAVENPORT
"I Made Signs Before I Could Talk"

SIGNS

COMMERCIAL AND ADVERTISING

ILLUSTRATING DESIGNING CARTOONING

3131 Cottage Grove Ave. Chicago, Illinois

Fig. 2 Jay Jackson, *Chicago Defender*, February 28, 1942

Fig. 3 Advertisement for H. George Davenport Signs, *Black's Blue Book*, c. 1924

he graduated in 1917. After serving in the U.S. Army, he returned to the city and eventually set up his commercial art studio. His main clients were the predominant black businesses of that time—banks, insurance companies, and firms that made cosmetics.

Not all Dawson's clients were based in Chicago. He worked extensively for Annie Malone's Poro Schools of Beauty Culture for which he did a series of newspaper advertisements on Famous Black Beauties in History and Mythology. He also created at least one advertisement for a hair straightener called Madagasco. In that ad he depicted two sphinxes, which aligned him with those black artists in New York who, under the influence of Alain Locke, were beginning to draw on Egyptian as well as East and West African motifs for their work (*Fig. 4*). Dawson also organized the Chicago Urban League's exhibit in the Social Science Pavilion at the Century of Progress Exhibition of 1933-34 and played a central role in designing the city's American Negro Exhibition of 1940, which showcased historical contributions of Negroes to American life. The exhibition poster was done by Robert Savon Pious, an African-American graduate of the School of the Art Institute who was working at the time for the Cuneo Press (*Fig. 5*).

During the Great Depression of the 1930s government-sponsored programs such as the Works Progress Administration created opportunities for white and black artists to work together under conditions of parity. Quite a number of African-American artists worked for the Illinois Art Project, a part of the WPA. The IAP included some divisions that related to design: posters, dioramas, applied arts, exhibition design, and advertising. The WPA was also instrumental in spawning the South Side Community Art Center, which opened in 1941. There African-

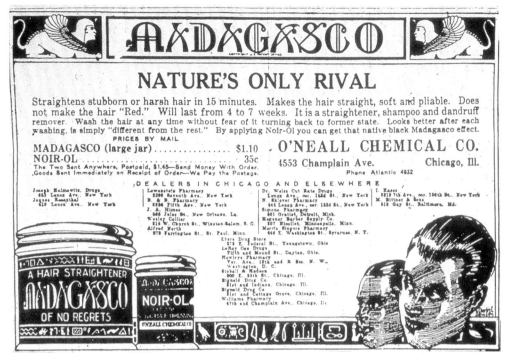

Fig. 4 Charles Dawson, Madagasco Hair Straightener, ad, 1925

American artists, young and old, could take classes, show their work, and meet for discussions. Although it began as a WPA-sponsored project, the Art Center redefined itself after the WPA ended and became a place whose programs were no longer shaped by government policies.

Most of the African-American designers who came up in the 1940s and 1950s had some involvement with the Art Center, either as students, administrators, or participants in its many events. One artist who was central to the Center's activities was William McBride. He was an art promoter more than an artist or designer but he did have a strong sense of style and produced important graphic works for the Center's Artists and Models Balls and for other projects such as the Mildred Haessler Dance Company (*Fig. 6*).

A number of artists who had worked at the Center joined the Johnson Publishing Company. With its family of nationally-distributed magazines for African-American readers including *Negro Digest*, *Ebony*, and *Jet*, as well as its book publishing division. the Johnson publishing empire enabled designers like Herb Temple and the late Norman Hunter to develop their careers with the company, while others like Vince Cullers and LeRoy Winbush gained valuable experience there and then moved on (*Fig. 7*).

After graduating from high school, Winbush became a sign painter and later got a job doing the signs for the Regal Theater. At the Regal he met all the prominent black entertainers from Lena Horne and Billy Eckstine to Duke Ellington. He then landed a position at Goldblatt's Department Store, where he became head of the section that produced the window displays for all the company's branches. In the early 1950s, Winbush left Goldblatts and established his own office, Winbush Associates. He staked out a distinctive clientele, the La Salle St. banks who hired his firm to design

Fig. 5 Robert Savon Pious, American Negro Exposition, poster, 1940

Fig. 6 William McBride, Mildred Haessler Dance Company, program book, n.d.

their window displays. Eventually Winbush Associates worked for just about every major bank in the city. Winbush built up a staff of African-Americans with multiple talents and then provided a full service for the banks that included concept development, exhibit construction, lettering, and installation (*Fig. 8*).

Winbush was also one of the few black designers to seek membership in Chicago's mainstream design organizations, the Society of Typographic Arts and the Chicago Art Directors Club. He became extremely active in both organizations, although it took him seven tries to gain entrance to the Art Directors' Club, where he eventually became its President. Winbush occupies a special position in the history of African-American design in Chicago because of the aggressive and ultimately successful stance he took to practicing in a white-dominated design community.

Beginning in the late 1940s, black students studied design at various schools in Chicago. These include the School of the Art Institute of Chicago, the Ray Vogue School of Art, the American Academy of Art the Institute of Design and more recently Columbia College and the University of Illinois, Chicago. African-Americans have studied art at the School of the Art Institute for more than a century and began to study commercial art and product design there with some frequency in the 1950s. These students included Harold Rollins, Don Patton, Vince Cullers, Herb Temple, and Chuck Harrison. Others such as Tom Miller and Emmett McBain studied at the Ray Vogue School of Art or the American Academy of Art where, in the early 1950s, they were sometimes the only African-Americans besides the janitors.

The Institute of Design was founded initially as the New Bauhaus in 1937. Beginning in the late 1940s, after the death

Fig. 7 Herb Temple, *Ebony*, cover, August 1969

Fig. 8 Winbush Associates, design for bank window, n.d.

of its first director László Moholy-Nagy, a number of African-Americans came to the school to study both photography and design. These included Jim Taylor, Ted Williams, Lacey Crawford, Fitzhugh Dinkins, and Eugene Winslow, whose career is of particular interest. Even by the 1950s, few employers in Chicago were willing to hire a black designer, although a number of students had proven their abilities in the city's best art schools. When Winslow left the Institute of Design around 1951, he did get a job in a firm owned by the father of a white classmate. It was not one of the highly visible Chicago design offices where he was certainly qualified to work but rather a more mundane one that provided over all marketing services for its clients. Winslow's designs were considered excellent but he was asked to work behind a screen so that white clients wouldn't see him when they came to the office. After some years of working for offices owned by white people, he returned to the black community where he created several calendars for the Supreme Life insurance Company with his portraits of famous African-American men and women from the past. He was also actively involved with a publishing company, Afro-Am, that produced educational materials about famous black leaders for school children (*Fig. 9*).

 After many rejections when he left Ray Vogue in the early 1950s, Tom Miller got a job at Morton Goldsholl Associates, one of the city's top design firms. In Goldsholl's office, he did everything from package design to logos and props and backdrops for animated commercials. Whereas other designers left Goldsholl to start their own businesses and thus gained recognition that way, Miller, who could work easily under Goldsholl's patronage but who would no doubt have faced serious obstacles had he

Gwendolyn Brooks
(1917-)
POET

Gwendolyn Brooks was born June 7, 1917 in Topeka, Kansas; spent most of her life in Chicago; won the Merit Award of Mademoiselle magazine with her first volume of poems *A Street in Bronzeville*; won the Pulitzer Prize for Poetry in 1949 with her second volume *Annie Allen*; received two Guggenheim Fellowships, was awarded a prize of $1,000 from the American Academy of Arts and Letters; received the Eunice Tietjens award from *Poetry* magazine; won the Poetry Workshop Award for four years; wrote *Bronzeville Boys and Girls*, *The Bean Eaters*, *Selected Poems*, and the novel, *Maude Martha*.

Russell L. Adams, *Great Negroes: Past and Present* ML-1 (Chicago: Afro-Am Publishing Co., 1969), *Who's Who in America*, Vol. II (Marquis-Chicago 1960); *Poetry Magazine*, 101-305 38, (March 1964)

1969, Afro-Am Publishing Co., Inc., Chicago, Ill.

Kent smokes...
and that's
where it's
at.

KENT

Fig. 9 Gene Winslow, Afro-Am poster, n.d.

Fig. 10 Vince Cullers Advertising, Emmet McBain, art director, Kent Cigarettes advertising, 1960s

tried to start his own business and seek white clients, was little known by his Chicago peers, even though he was responsible for many important projects in the Goldsholl office including its well-known redesign of 7-Up's packaging and corporate identity.

One result of the Civil Rights and Black Power movements was the emergence of several black advertising agencies that received much of their business from white clients who hired them to speak in a familiar language to the black community. The first of these agencies was headed by Vince Cullers, who had struggled since the late 1940s but was able to expand in the 1960s due to business from Lorillard and later from other companies such as Kellogg. The Cullers Agency also created product identities for Johnson Products, notably its new hair care line known as Afro-Sheen. The militancy of the 1960s provided an opportunity for the agency to create advertisements with stronger images of African-Americans than had been previously seen in American advertising. Under the guidance of its brilliant art director Emmet McBain, the Cullers agency produced the first advertisements that showed African-American men and women with Afros and African-inspired clothing (*Fig. 10*). One ad for Afro-Sheen even had a copy line in Swahili.

The accomplishments of Winbush, Winslow, Miller, Cullers and others makes it clear that many blacks could have been more successful as designers had there not been so many obstacles in their way. Even in the militant 1960s, when racial barriers were breaking down in many professions, little changed in the Chicago design community. The struggles of Chicago's black designers help put into perspective the extraordinary achievements of Sun Ra and Alton Abraham. Not only was the Arkestra's music groundbreaking but the graphics for

the album covers were also unlike anything else being done in the recording industry.[3] The closet to them were the mystical paintings of Richard "Prophet" Jennings for two of Eric Dolphy's albums on Prestige in 1960. However, these were exceptions in the mainstream jazz record industry, whereas the far out illustrations and lettering of Claude Dangerfield and other artists associated with the Arkestra were the norm for El Saturn (*Fig. 1*). They defined the label and signified the independence and complete originality of Sun Ra's music.[4]

The artistic production of El Saturn existed in its own space and defied the visual norms that the predominantly white culture maintained for jazz album covers and for graphic design in general. And yet this production must also be understood as part of the struggle by other black commercial artists in the city to make a place for themselves and their work within a wider cultural milieu. As such it was the underground of the underground.

1. Allan H. Spear, *Black Chicago: The Making of a Negro Ghetto, 1890-1920* (Chicago: University of Chicago Press, 1967).

2. Roy Utley, *The Lonely Warrior: The Life and Times of Robert S. Abbott* (Chicago: H. Regnery Co, 1955).

3. For a discussion of jazz album cover design, see Clarisse Kowalski Dougherty, "The Coloring of Jazz: Race and Record Cover Design in American Jazz, 1950-1970," *Design Issues* 23 no. 1 (winter 2007): 47-60.

4. Examples of the finished album covers as well as preliminary cover art and sketches are reproduced in the catalog *Pathways to Unknown Worlds: Sun-Ra, El Saturn and Chicago's Afro-Futurist Underground, 1954-68* (Chicago: Whitewalls, 2006).

Aye, Black-light painting, c. 1972. Photograph courtesy Chicago Jazz Archive, Special Collections Research Center, University of Chicago Library.

The Spiritual Musician

BY PHIL T. COHRAN

It is clear, to even the most careless observer, that we live in a time of great conflict and upheaval. The pattern of unusual natural phenomena and unusual human behavior extends from the level of neighborhoods throughout the planet. Violence is no longer an undercurrent but has surfaced for its share of man's blood. The vibrations of doom and fatality is gaining the majority vote in the house of ether. This is truly a time of "change," we can all agree, but what is the role of the musician in such a time?

Should we grasp the increasing pleasures as a drowning man grabs a straw? Should we become musical photographers and reflect only the fear and frustration that is on the agenda? Is there any clear-cut path to follow? These questions bring into focus the principal of "length of barrel" that was advanced by some unknown thinkers of the past. A bullet fired from a pistol could not be expected to have the accuracy of that same bullet fired from a rifle. Why? Because of the length of barrel. This same principal applies to our question of today. If we want to know where we're going, we must learn where we have been. If our knowledge of the past is shallow or incorrect, then it follows that our aim for the future is shallow or incorrect. Also, if we understand the last one hundred years clearly, it is a help, but one thousand would be far more informative. Ten thousand years would put us in select company and one hundred thousand years, with any amount of details, could come only from inside.

There are many sources of information, about the past, at our fingertips if we are concerned. The sky holds all of the secrets of man's existence. A study of the movements and relationships of the celestial bodies reveals the eternal order and discipline that has always been and will always be. The birds that fly and sing are symbolic of the creation and are a fountain of knowledge to those who will drink. All of nature is a source enlightenment to the wide of eye. The museums, libraries, observatories, aquariums, zoos, etc. offer a wealth of information to the interested musician. But perhaps the greatest source is from people themselves; old folks, children, the blind or afflicted, alcoholics, addicts, squares, fools, and other musicians. All kinds of people carry different pieces to the puzzle. And the puzzle can only be pieced together by the sound mind.

All these sources of information have little value without a knowledge of self. We can pinpoint our entire obligation as beginning by acquiring self knowledge or understanding. The yoga instructor or Guru seeks to reveal our inner light. Many spiritualists approach self through universal mind. In psychology, the direction is through the relationship of the conscious to the subconscious. There are many approaches to self knowledge but they all involve highly sensitive degrees of measurements. Because of these fine degrees of measurements, we have to cleanse our blood. Since we use our blood for thinking and it circulates throughout the body, we have to cleanse our bodies also. In other words, we have to first elevate our bodies to a peak of physical condition and this allows our minds to elevate to the proper level. This is the law for all who travel the higher path. Not only must we extricate the foul foods from our diets, but we must depart from foul words and thoughts, for they represent the borders that we seek to overcome in other directions. These things limit us to

the lowest plane of man's existence. In reality the laws or rules for self-knowledge are parallel to the rules of mastery of any musical instrument. This makes it comparatively easy for musicians to attain this understanding.

It has been said many times that music is a language or a vehicle of expression. If this is true then what shall we express through this medium? Our fears, inhibitions, desires, hatreds, beliefs, or understanding? Confucius said, "The wise man seeks by music to strengthen the weaknesses of his soul. The thoughtless one uses it to stifle his fears." When we look at the various primitive (so called) cultures around us today we find that, like the ancient highly evolved cultures, music plays a greater functional role in the daily lives of the people. Also, the music is controlled to a greater degree than in Western culture. A careful study of any or all of the great advanced cultures of the past will reveal a detailed use of music as a science. This science is rooted in the mathematics of the open-string (harps, zithers, tamburas, etc.). Only a fool or child would put pedals on harps. There are many instances we could cite to prove the importance of music to a people's strength and spirit. What it all adds up to is that the musician has a great responsibility to elevate his people as he entertains.

Those who differ and argue that the musician's responsibility is to elevate all people must not misinterpret the statement. The common denominator of man is his seed; no one would deny this. The seed is the doorway through which we travel the length of the barrel. This seed has characteristics, vibrations, and identity. The seed determines the frequency to which we are tuned and as a result we express ourselves through these vibrations. It is true, any music that comes out of the black people of America seems to strike a sympathetic response in all people. But this is so primarily because the source of the music, Africa, is the trunk of the musical tree and other musics are the branches that stem from that same trunk. History shows this for all to examine. Getting back to the responsibility to elevate, the condition demands that we respond to this need. If we have the intellect, sincerity, and discipline to reach the higher degrees of musical mastery, then we must step to the spiritual plane. Only then can we set an example and be a source of inspiration and understanding in these times.

The environment that most of us are confronted with, in the cities, appears to be hostile at first glance. It could be described as suffering from a materialistic hangover, the binge is past. But a closer check reveals that even the fools are getting suspicious. People sense that they are being led into false channels to rob them of their inner strength. They play the game only because they have perfected it. The spiritual musician has a great opportunity and obligation to prove that reality exists, that there are definite truths, that there is beauty and love, that life is full and rewarding through old age. Say these things in music and no one can dispute them or dilute them. This has been the spiritual musician's or priest's job since ancient times; to keep reality before the people. And he has an advantage in that his inner self and his people are one.

Written for Change *magazine in January 1965*

"TAKE A TONE ADVENTURE INTO THE FUTURE"

**FAR-OUT AS THE WEST COAST JAZZ...
BASIC AS BASIE...LIVE CONCERT FI!!!**

A Fantastic New Jazz Conception by SUN RA, -SUN God of Jazz

by Bill Coss,
Metronome Magazine

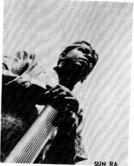

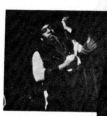

SUN-RA
and His Arkestra

SUN RA

"THERE IS NOTHING NEW UNDER THE SUN, BUT THE MUSIC OF THE SUN IS NEW BECAUSE THE
SUN IS THE PACE–SETTER OF TOMORROW."

PAT PATRICK

JOHN GILMORE MARSHALL ALLEN

Will play for: Parties, Concerts, Dances, ect.

THE SUN RA ARKESTRA IS NOW AVAILABLE FOR BOOKING

CONTACT: ATRA PRODUCTIONS
8122 SO. KIMBARK AVE.
CHICAGO, ILLINOIS

Saturn poster, early 1970s. Courtesy Chicago Jazz Archive, Special Collections Research Center, University of Chicago Library.

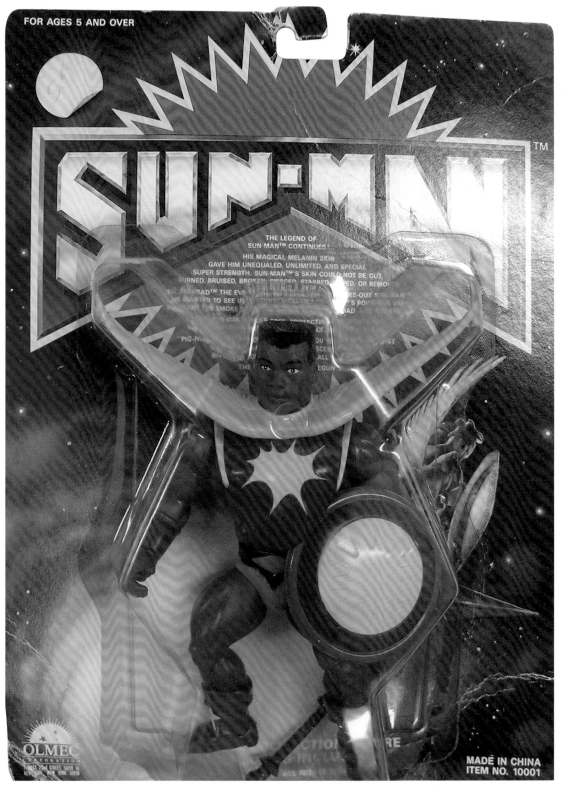

Sun Man action figure, c. 1985

The Legend of Sun Man Continues

BY KERRY JAMES MARSHALL

His Magical Melanin Skin gave him unequaled, unlimited, and special
super strength.

Sun Man's skin could not be cut; burned; bruised; broken; pierced
Stabbed; ripped; or removed.

So Pig-head, the evil Wart, was plotting to smoke-out Sun Man
He wanted to see if he could weaken Sun Man's powerful skin
through the smoke from the drugs pig-head had just cooked up.

But Sun Man flies free, protecting the right for the galaxy-trefixa to
exist in peace.

His rap is clear;

Pighead, listen. You're bad luck. You won't win, so just give up.
Sun Man is on the scene to stay. My good powers shall rule all the way.

The battle has just begun!
 —From the "Sun Man" toy package, 1985

If you had been born a black man in Birmingham Alabama, 1914, with ambiguous
sexual orientation, you should be forgiven a few eccentricities on general principle.
Given the levels of stress Negroes had to negotiate in the "land of the free," it is a
wonder more Black people didn't manifest dissociative tendencies. The psycho-
brutality of knowing you could never be truly free within a White Supremacist national
structure required a great many creative strategies for coping. People of color didn't
seem to fare much better anywhere else in the world either. Everywhere you looked,
European colonialism had an iron grip on the self-respect of Asians, Africans, and
Latin Americans. There was no place on earth, it seemed, where colored folk enjoyed
the right of self-determination.

At least a decade and a half before the phrase "free your mind, and your ass will
follow," rallied '70s "Funksters," Herman "Sonny" Blount, took off, and went about
as far out as any, dark skinned, black person ever had. "I'm not from around here," he
would say. "Saturn," the domain of the "Angel Race," was his home. For the average
"negro," of the '60s, this just sounded crazy. It seemed a bit ridiculous to me too.

I had heard of Sun Ra before long I knew anything about him or listened to his
music. He had a reputation for being "strange and outrageous," a comic figure to some,
visionary for others. When I finally encountered his music, it sent my head to spinning.
I thought, if the figure he cut, matched the descriptions, I'd heard, or was in any way
as weird as the music was incomprehensible, maybe Mr. Ra, just wasn't gonna be for
me. Before I understood ideas about transcendence, free Jazz, experimental music, and
the like, I had no intellectual frame in which to conceptualize Sun Ra's project. He was
nothing like other Jazz musicians, even ones like Coltrane, who also played into and out
of cosmic zones few others could enter. After some time, I began to see that Ra was not

just some kook in a cape and sequins. His persona and performance were not an isolated, "whacky," phenomenon completely detached from history, Black culture, or reality.

Reading history, taught me that current attitudes, ideas, and behaviors, are linked in a continuum that stretches back for millennia.

Like David Walker, the 19th century pamphleteer, who's *Appeal to the Coloured Citizens of The World*," published in Boston, 1829, Sun Ra is part of a long tradition of radical, Black Liberation, ideologues. And, with his Egypt-o-mystical references, is clearly sympathetic to foundational principles in Afro-centric philosophy. Critical to each of their beliefs, is the need for a complete reformation of the enslaved Black mind, body, and spirit. The prelude to this total transformation is analysis of the situational problem. Walker's *Appeal* is divided into four Articles mirroring the Constitution of the United States, which he critiques. Each section deals with a particular aspect of the Black condition. "Article I; Our Wretchedness in Consequence of Slavery;" "Article II; Our Wretchedness in Consequence of Ignorance;" "Article III; Our Wretchedness in Consequence of the Preachers of the Religion of Jesus Christ;" and "Article IV; Our Wretchedness in Consequence of the Colonizing Plan." On these accounts, seen as stirring the hearts of slaves to insurrection, David Walker was hanged. The necessity of keeping very close council, among a small, disciplined, group is essential in such an enterprise. Walker was ultimately betrayed by the adversary he feared most; "one who receives gifts of old coats, and the like from the master," a negro comfortable with his enslavement. Parallels can be found in the almost monastic, nature of Sun Ra's Arkestra; communal living, few distractions, rigorous, disciplined, practice and study.

I am not going to suggest that Sun Ra read Walker's *Appeal*, or even knew of it. Odds are, he had not. What I will say, however, is that the young Sonny Blount would, very likely, have been exposed to similar ideas about self-actualization circulating in the churches, barber, and beauty- shops of Black America. In the 1920s, there was Marcus Garvey with his United Negro Improvement Association, and Alain Locke's "New Negro," of the Harlem Renaissance. The Nation Of Islam was beginning to take shape in the 1930s demonstrating success rehabilitating the worst of the worst criminals and ne'er-do-wells. What these movements had in common was the notion that black people, the "negro," had to be made over, "born again" as newly self-possessed creatures ready to take their rightful place among the leaders of men.

There is a heavy dose of messianic wishfulness in all their preachments. A combination of real-politic and myth-o-poetics. With few exceptions, most Black New Age philosophies had decidedly religious predilections. This is easy to understand, given the church's centrality as a place of relief, such as it was, from the daily plantation grind. Spiritual salvation offered the most tangible hope of freedom for generations of Black people during and after enslavement. As a result, preachers, "the leaders of the flock" have long been the highest ranking, most respected, members of the Black community.

This spiritual longing, dependence, even, left many Black people doubly vulnerable under the system of "White Supremacy." Beaten and brainwashed into submission, suffering from inferiority complex, many were further exploited by unscrupulous ministers simply trying to get over. In the Black community, more than in any other, I know, opening a church is an entrepreneurial endeavor, a popular small business opportunity. It is not uncommon to see three, four, even as many as five, little churches on a block in some

neighborhoods. You've got to figure, these people are sorely in need of something, if they require this much ministering. Not all enterprising pastors are hucksters, though. A great many have an earnest commitment to the well being of their followers. Even those of questionable anointment, at the very least, provide a space and an opportunity for congregants to fellowship, and release pent up stress two or three times a week. This is why a good bit of Black expressive culture has its roots in the church.

Two flamboyant Black preachers, who presided over large congregations, and vast religious empires, were prominent during the years before Sun Ra became a "space man," and, I believe, had, at least, an indirect impact on his ambition and style; Charles "Sweet Daddy" Grace, and George "Father Devine" Baker. Both seemed to have successfully transcended the institutionalized limitations of being a "negro," and achieved success on a grand scale. Although born out of the Black religious tradition, and established in places like Harlem, and Washington, D.C., they attracted numerous white followers as well. Both men, allowed the notion that they could be "God the Father," himself, to hover, unresolved about their ministries. I think it is interesting that Herman Blount also appropriated the mantle of a god when he took the name, Ra.

Furthermore, "Daddy" Grace, in particular, is known to have been as extravagant as he was theatrical, dazzling his followers with his long hair, multicolored robes, and tri-colored fingernails. In a famous photograph of him, by James VanDerZee, Grace's costume looks almost biblically cartoon-ish. At its height, in 1927, "Daddy" Grace's "United House of Prayer for All People of the Church on the Rock of the Apostolic Faith" claimed 500,000 members in sixty-seven cities. (*Encyclopedia Africana*) Both the good deeds, and the antics of "Daddy" Grace, and "Father Divine" would have been talked about in almost every black town. It would be virtually impossible for a searching, creative soul like Herman Blount not to have noticed and been impressed.

So, why did "Sonny" Blount choose the Egyptian style instead of the traditional Baptist, Christian model? I believe Sun Ra was inspired by early Afro-centric teachings promoted by Elijah Mohammed, through the Nation of Islam, and self-taught historians like J.A. Rogers. *The Miseducation Of The Negro*, by Carter G. Woodson, creator of Negro History Week and *Stolen Legacy*, by George G. M. James were also highly influential in the emerging field of Afro-American studies. The Black Muslims taught that the "Black" man was the original man. They said, "Egyptian civilization," which European historians managed to de-link from the "Mother Continent" was a Black, African, civilization. For a people desperate to recover a sense of dignity, this is pretty great stuff.

For Afro-centrists, the past and the future meet in Egypt. Magic and science fiction merge to explain how so grand a civilization could emerge so long ago. They were extraterrestrials, from Mars...They used levitation to build the pyramids...The Egyptians had gliders and helicopters....

These are the mysteries, the lost knowledge of the ages. This, I believe, is the calling of Sun Ra.

"You can call me Mr. Ra, and you can call me Mr. Re, or you can call me Mr. Mystery"
—Herman "Sonny" Blount, a.k.a. Sun Ra

$2.50

THE IMMEASURABLE EQUATION
by Sun Ra

ALL EQUATIONS TOGETHER ARE TWO IMMEASURABLE EQUATIONS
BECAUSE OF THE IMMEASURABLE PRESENCE OF THE NON-BEING
IN DUALITY OF THE BALANCED ONENESS OF THE TWO.

publisher:

IHNFINITY INC./SATURN RESEARCH
P. O. BOX 7124
CHICAGO, ILL. 60607

Book cover, 1972. Courtesy Chicago Jazz Archive, Special Collections Research Center, University of Chicago Library.

Sun Ra: From Negro to Black

BY CALVIN FORBES

Sun Ra's mantra of "space is the place" and his ruminations on ancient Egypt have always been good for either jump starting or ending a conversation about the man and his music. Was he joking, was he putting us on? Was he just being spacey? Most people who are into Sun Ra's music generally shrug off Sun Ra's attempt at astral-myth making, lumping Sun Ra's riffs on ancient Egypt and his supposed intergalactic birth into the same bag, with a wink and a nod. Fans of Sun Ra's music usually pay more attention to Sun Ra's badass costumes than to his ideas about the past, present and future, and how all three intertwine.

Would Sun Ra have been just another brilliant eccentric without his music? Based on a survey of his non-musical writings, Sun Ra had a lot on his mind besides making music. Among other topics, Sun Ra had a great deal to say about race. Specifically he seems intensely interested in the craziness African-Americans were living through during the first decades of the 20th century. Sun Ra obviously meant his writing to be read and taken seriously; he wasn't putting pen to paper only for his own personal instruction. He wanted to be part of a dialogue about racial matters; he wanted to be part of the solution.

During the Harlem Renaissance people with Sun Ra's inclination to discuss, analyze, and act on black history were called Race Men. Sun Ra fits this description to a T. Sun Ra was obsessed with the plight of the Negro, which was Sun Ra's preferred term for black people up until the '70s. When Sun Ra was growing up in the 1920s for another black man to call a Negro black would have been cause for fisticuffs. Same people, different labels, same problems. Today we struggle with another word to describe black people, the dreaded N-word.

A Race Man can be loosely defined as someone preoccupied by what we now know as African-American history or black history. Some of the Race Men were women, like Ida B. Wells. Sun Ra's ideas about history are riddled with fantastical interpretations, but nonetheless they reveal a terrible truth: African-Americans, due to our history of bondage and subjugation in America, were/are lost. A lost tribe, not the tribe of Cain, but nonetheless seemingly destined to intellectually and, at times, physically wander post- Civil War America (and increasingly the world as well) looking for a place to call home, for our roots.

What can Sun Ra's poetry and aphoristic writings, both published and unpublished, written over decades, tell us about African-American history? Or to put it another way, what can Sun Ra's musings tell us about a strand of thought found in certain segments of the African-American community between and after the two world wars? Sun Ra's writing bears witness to the way many black people understood and misunderstood what was happening to African-Americans before the progress of the 1960s civil rights movement changed everything, not always for the better. Whether they were street corner intellectuals or college professors, whether their worldview was wrong or right, is beside the point. Either way there's a lesson to be learned. Like his music, Sun Ra's verbal musings are the product of a prodigious mind,

which is one of the reasons we listen to his music and should seriously think about what he has to say about race.

Sun Ra's sensibility was both traditional and radically futuristic. Even his chosen name Sun Ra (his former moniker was Herman P. Blount) simultaneously takes us back to the African past and turns us sharply towards the Afro-centric present with our propensity for African sounding names. Sun Ra seems to have had a natural affinity for the popular as well as the avant-garde. He was comfortable with his many contradictions. On the CD *Purple Night* Sun Ra is as at ease with his own tune "Friendly Galaxy" as he is with "Stars Fell On Alabama," a 1934 Tin Pan Alley tune penned by the song writing team of Frank Perkins and Mitchell Parish. Sun Ra not only plays the piano but sings on "Stars Fell On Alabama," sounding irrepressibly like a down home funky crooner. Sun Ra felt at home in many different worlds. Perhaps Sun Ra thought "Stars Fell On Alabama" was a comment about his arrival on planet Earth, in the city of Birmingham, Alabama in 1914. You can hear a wide range of white and black American popular music and the prospect of future black musical styles in Sun Ra's music, including funk. And why not invoke the Mothership of George Clinton's Funkadelic space odyssey? And while we're at it, let's include the "Purple Rain" of Prince as well as George Clinton's "One Nation Under A Groove." What planet was James Brown from? All three have more in common than the ethos of costuming and tongue-in-cheek chic. There must be a cosmic connection between these later day funk masters and Sun Ra, if only an unconscious one. Let's call it a tradition. Yet the Mothership was a space ship and not a slave ship.

Negro and black might refer to the same people, but they don't describe the same consciousness. Nowadays, to call a black man a Negro is tantamount to saying he can't dance. At the same time, Negro Gospel Music hits the ear different than Black or African American Gospel Music. In "Message To Black Youth" from his poetry chapbook *The Immeasurable Equation* published by Infinity Inc./Saturn Research in Chicago in 1972, Sun Ra sends out this positive vibe to black youth: "Never say you are unloved/I love you". In his earlier writings Sun Ra doesn't show much love for the Negro. He spends most of his time analyzing what's wrong with the Negro. Is this a case of blaming the victim? If a white person had said some of the things Sun Ra says about Negroes we wouldn't have any trouble ignoring such opinions. In sum, Sun Ra's early writings reflect a repetition of the familiar "Negroes (you can substitute the N-word) ain't shit". What was Sun Ra up to? Did his frustration with being black in a racist America turn his rage inward? He wouldn't be the first to do so, and he won't be the last. One of his early works is entitled "A N----- is a mess."

Sun Ra explores a similar terrain of another autodidact, J.A. Rogers, who was originally from the West Indies, and was also based in Chicago between the two world wars. Both men were interested in history, real and imagined. Rogers was the author of titles such as *One Hundred Amazing Facts About the Negro*, *World's Greatest Men of African Descent* and *Nature Knows No Color line*. The titles are revealing; Rogers was trying to undo the harm done by the white histories of blacks or Africans or Negroes. J.A. Rogers and Sun Ra went down different paths, one towards a scholarly

rejuvenation of the Negro's reputation, the other towards a more pointed critique of the way black people responded to their oppression. Yet J.A. Rogers and Sun Ra were asking similar questions. Why are black people so beset? Why are black people at the bottom of the barrel? Or why are black people like those proverbial crabs in the barrel? The fact that we most recently witnessed the debate between Bill Cosby and Michael E. Myers over who or what is to blame for the continued failure of significant numbers of African Americans to break out of the cycle of poverty and anti-social behavior is telling and should be shocking. What has changed? Who's going to take the weight?

To put all of this self-scrutiny into a historical context we have to understand what happened to African-Americans post-Civil War era, during and after Reconstruction. It was like post Katrina, a parallel story of neglect and abandonment, albeit on a much larger scale. And it was not that long ago. African-Americans of Sun Ra's generation could have been children of slave grandparents, or at least lived in a community where the consequences of several 19th Supreme Court rulings, stating in black and white that the US constitution did not guarantee equal rights and protection under the law to African-Americans, were apparent.

When the Civil War ended black people were optimistic, ready to let bygones be bygones; schools started by African-Americans and liberal whites flourished, as well as black economic activity in the segregated south and north. Black people thought that if they pulled themselves up from their bootstraps and were law-abiding citizens, everything given time would be okay. Yet by the late 19th century, black people were waking up to see their dreams crushed under the foot of the Klan and its ilk while the white folk who were supposed to administer the law sat on the fence or looked the other way. No wonder Sun Ra looked to outer space for answers. God wasn't answering, and neither was the American system of justice.

Besides having their hopes and independence bashed (self-help societies were a staple of post-Civil War southern black society) and dashed, African-Americans had to grapple with another set of changes. Some black people must have thought (or prayed) that by deemphasizing their blackness and curtailing some inherited and chosen cultural differences things would soon get better. Around this time is when we became colored people, a term that, among other things, suggested racial mixture. It was also a not so subtle effort to down play our African heritage. But the racial barriers weren't lowered, regardless of your education or the hue of your skin. Yet, black people's multi-racial heritage was a reality. Sherwood Anderson, the noted white writer of Winesburg, Ohio, a classic of white American literature, has something to say on this topic.

In his 1926 essay "The South" Sherwood Anderson writes: "The negro [note the lack of the capital N] race in the south is so apparently getting lighter. Northern travelers can't do it all. Many of the negro women, in the cities, on the country roads, riverboats, about houses where you go to dine, splendid creatures. It's often said such and such a white man has a touch of the tar pot. It doesn't come in through white southern women. White blood constantly creeping in from somewhere."

Regardless of the source, black Americans, like many people of African descent in the Americas, are a mixed-race race people. The children born of white and black (and

Native American) liaisons for the most part married or mated with blacks, generally darker, back to the black, so to speak. The variations found today and in Sherwood Anderson's time in black people's skin tones, even within the same families, is partly the result of racially mixed people marrying and mating with darker skin people and is not simply the results of white men spreading their seed willy-nilly down through the years. This aspect of how we came to be who we are isn't often discussed and is greatly misunderstood. This might help explain Sun Ra's affinity towards Egypt; he was searching for an explanation for our complex racial history. Egypt in its ancient past as it is today was and is a racially mixed nation. Sun Ra looked around saw his fellow "colored" mixed race black Americans and concluded that they looked like Egyptians with skin tones shaded from light to dark. This might help to explain why Sun Ra took his chosen name from Egyptian mythology.

Okay it's a stretch, to link black Americans directly with Egypt, since our African ancestors came from the West Coast of Africa. But Egypt is in Africa, just like ancient Rome and Athens were in Europe, and if white Americans can lay claim to Rome and Athens, why isn't it reasonable to assert that Egypt was an African civilization, which it was, and for black Americans to claim Egypt as their own? You have to admit, it makes some sort of sense, however convoluted. This effort further underscores why the metaphor of searching for one's roots continues to be such a compelling one for African-Americans. Sun Ra seems to have taken seriously his idea that "the secret of the racial origin of the Negro is in Asia; his early history began there" which is what he wrote in one of his broadsides. If you can believe that black Americans came from Asia, and it is worthwhile noting that the Middle East and Egypt are geographically the gateway (from Europe) to Asia, then it's not that far a stretch to believe that an American Negro came from outer space.

Sun Ra was not alone in looking for answers in myth making, whether earthly or not. Another southern mystic who settled in Chicago around the same time was Elijah Muhammad. Originally from Georgia, the founder of the Nation of Islam also made Chicago his base of operations during the 1930s. What is it about Chicago that it helped to nurture such men as J.A. Rogers, Sun Ra and Elijah Muhammad? What do the founder of the Nation of Islam and Sun Ra have in common? Both men not only changed their birth or slave names and took on new personas, but they also resorted to mythical answers to the same question: why is the Negro so beset. If you read any of the Nation of Islam publications up until Elijah Muhammad's death you will find a constant barrage of articles taking the American Negro to task, which sounds eerily similar to Sun Ra's outbursts against the Negro. Something was in the air in Chicago, beside the smoke from the steel mills.

Sun Ra though doesn't seem to have been an overt activist, unless you want to call having his own record label, printing up and dissimulating volumes of his writings, political social activism. Sun Ra was very much socially engaged in his thoughts and actions. Unlike Elijah Muhammad he doesn't start a movement, an organization, though it could be argued that Sun Ra had his followers. Sun Ra, like Elijah Muhammad and later Malcolm X (who also changed his slave name) devoted a lot of his energy to

criticizing Negroes. Sun Ra puts it this way: "the problem with the Negro is that he is always wailing."

Sun Ra's riffs on the Negro Problem remind me also of some of Richard Pryor's jokes. What Richard Pryor's jokes and Sun Ra's takes on the Negro have in common is the same drift: they are both asking what's wrong with these crazy Negroes (substitute the N-word if you wish). Negroes are always wailing, Sun Ra says, so much so that they seem comical. Richard Pryor built a career on telling such jokes and raising questions about what it means to be African-American in the process. Such questions though can do mind-boggling things to your self-image. Maybe this is what Richard Pryor realized when he said he would stop using the N-word (not Negro) after returning from his first trip to West Africa. Visiting Africa had a similar redemptive effect on Malcolm X. Similarly important is the journey Sun Ra traveled while on this planet from Negro to black for it tells an all too familiar story.

El Saturn Records

"Beta Music For Beta People For A Beta World"

4115 So. Drexel Blvd.
Chicago 15, Illinois

I, HOBART DOTSON, AS OF THIS 24th DAY OF MARCH, 1959, DO HEREBY GRANT TO ENTERPLANETARY KONCEPTS, THE RIGHT AND PERMISSION TO PUBLISH MY ORIGINAL COMPOSITIONS "ENLIGHTMENT" AND "YOU NEVER TOLD ME THAT YOU CARED",

Hobart Dotson

Enlightment

BY TERRI KAPSALIS

With lyrics by Sun Ra and music by Hobart Dotson, "Enlightment" was copyrighted in February 1959. That same year, Saturn records released "Enlightment" on *Jazz in Silhouette.* The Library of Congress houses a copy of the sheet music with lyrics. The title, clearly written in Ra's own hand multiple times, is "Enlightment," a fact confirmed by Hobart Dotson's letter granting his composition's publication rights to Enterplanetary Koncepts. However, after its 1970 release on Shandar with John Gilmore and June Tyson on vocals, "Enlightment" disappears. It undergoes an exhaustive spell check and appears as "Enlightenment" in virtually all future re-issues and discographic references, including the B side of a Saturn single from which the Dotson credit is also missing. Even though the wordsmith Ra clearly chose the title, "Enlightment" for Dotson's tune, that pesky second "en" kept sneaking its way back into Ra's arrangement of letters, resurrecting the old standard "enlightenment."

When writing of the phrase "Jesus saves" in one of the typed broadsheets he would distribute while open air preaching on Chicago's south side, Ra scolds his imagined audience: "You don't know who Jesus is, you haven't even looked in a good dictionary to see what 'save' means. Actually the word 'save' has more than one meaning. Did you know that? The word 'save' has more than one meaning!"[1] Does this sound like the writings of a man who didn't know how to spell the word "enlightenment?" Rather, Ra might have looked up this word in the dictionary and foresaken its 18th century rationalist roots for its lesser known, now extinct, cousin, the word "enlight."

Now, "enlight" and "enlighten" share a number of meanings ("to shed upon," "to illuminate"), but "enlight" offers the additional meanings "to kindle" and "to cause to shine." To kindle, as in smoke and fire. As Ra's lyrics describe, "The fiery truth of Enlightment." To shine, as in that giant ball of fire after which Ra has named himself. A line from Alexander Pope is provided as a usage example in the *Oxford English Dictionary*, "That sun...Enlights the present, and shall warm the last."

In 1993, John Corbett and I met up with Sun Ra at Chicago's O'Hare Airport and joined him and saxophonist, Noel Scott, in the back of a black limousine en route to their One Mag Mile hotel. Ra wore a leopard skin cape, casual attire befitting Egyptian royalty. While Scott was transferring Ra from the limo into his wheel chair, Ra said, "We've been at this hotel before." Scott insisted they hadn't. "Oh yes we have," said Ra. "Last time we took the electricity with us." At the counter Ra was vindicated by the receptionist. "Oh yes," she said, "A big outage just about that time." Stories of fire and light. The one about the car filling with smoke after June Tyson's husband said something Ra didn't like. The driver pulled over and everybody evacuated the smoke-filled vehicle except a quiet Ra who sat in his seat until the smoke had cleared. Then there is the famous story reenacted at the opening of the film *Space is the Place*. A mobster threatens Sonny and the club fills with smoke, sending the customers fleeing. The accounts of Ra's powers with regard to fire, smoke, and electricity fit within the tradition of tales of adept yogis who could materialize and de-materialize objects, live

without sleep, and express themselves through the material world. Mind over matter. For Ra, sound over matter.

February, 1923. Young Herman "Sonny" Blount, about to be nine years old, might have seen the announcement in the *Birmingham Reporter*. Or maybe he heard it on news radio. The discovery of Tutankhamen's tomb. When light hit those gold and obsidian treasures, the West's imagination was inflamed. The future Sun Ra would have known that this Tutankhamen was only nine when he became prince. Nine was an important number for Ra. We learn in his broadside titled "The Wisdom of Ra" that "nine when it enters the realms of two begins to become greater than itself." "Enlightenment" has eleven letters. 11-2=9. "Enlightment" has nine letters.[2]

 With Tut, the West gained new insight into Ancient Egypt. Herman Poole Blount would follow his nickname, "Sonny," toward the sun, and turn to the ideas of Tutankhamen's immediate predecessors, the ones who took Ancient Egypt from polytheism and focused their energies on the single sun god, Ra, the creative force who brought light to the world, who gave life and warmth and wisdom.

H.P. Blavatsky wrote about solar theory. They had the same earthly initials: HPB. Herman Poole Blout and Helena Petrova Blavatsky, the 19th century Russian mystic and founder of theosophy. After riding horseback in a circus in Constantinople and giving piano lessons in London and Paris, Blavatsky arrived in New York and would become a famous medium. Her theosophy was a complicated stew that included Indo-Persian alchemical Tantric traditions with Zoroastrian material, 19th century occultism, and freemasonry. She described herself as a student of Indian Mahatmas and Tibetan yogis based in the Himalayas.

 Ra filled the front pages of the 1913 edition of Blavatsky's *Index to The Secret Doctrine* with notes and calculations. In black crayon, he permutes "ethiops" into "spode," investigating the semiotic relationship between biblical Africa and rhythm and blues (Sticks McGee's "Drinking Wine Spo-Dee-O-Dee"). In blue ball point, "Ertha Kitt" turns into "Ertha Kid" and then into "Earth Child." In the tradition of the theosophists and the kabbalists, Ra worked on words via permutations. Thmei Research, the Bible study group which included Ra and business associate and manager, Alton Abraham, focused its energies on ways to release the Bible's hidden meanings. Sure, the Bible was a standard, but like other standards, it could be re-arranged and reconsidered in any number of ways, offering up various interpretations.

 The stakes differed depending on who was doing the deciphering. In a broadsheet, Ra writes, "The bible is written in such a way that it has one meaning for the negro and another meaning for the white man." In another broadsheet titled "Why don't you turn again!" Ra addresses his African-American reader directly, connecting a black audience to the light, "What deep sorrow is it that gnaws at your heart? What deep un-named thing is it that makes you a nation set apart for scorn and poverty and misunderstanding? Ye cannot hide any longer. Ye are the light of the world." In another broadside, Ra writes, "Word of God is fire…Christ is the word…If you have Christ in

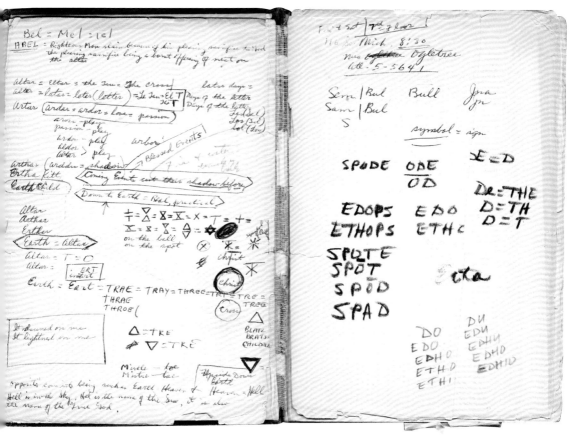

Sun Ra's notes in H. P. Blavatsky's *Index to The Secret Doctrine*, 1950s. Courtesy Chicago Jazz Archive, Special Collections Research Center, University of Chicago Library.

you, you have fire in you. Where there's smoke there's fire…smoke is a nickname for negroes. Therefore these words were written not for the world but for negroes only." On no uncertain terms, Ra made the connection between the "Negro" and the light by way of the bible.

Smoke rises. Light is not only the light that shines, but it is also "having little weight." Smoke is not heavy, it's light. Not heavy is not serious. Light is levity too. Lighten up! Light up! Humor offers relief from this grave world. This grave, gravity-filled world of the dead. Ra reminds us that people are not all earthbound. They can take off, rise up, and explore other planes of there. They can take flight. They can enlight.

In searching for the hidden meanings of the bible, Ra was working in an area akin to William Burroughs and Brion Gysin who asserted the power of such literary methods as the cut-up and the permutation. Burroughs and Gysin believed you could unlock words and release the truth, even foretell the future. In the bottom left corner of one of the Blavatsky Index pages, a little box in ball point surrounding two phrases in Ra's handwriting:

it dawned on me
it lightned on me

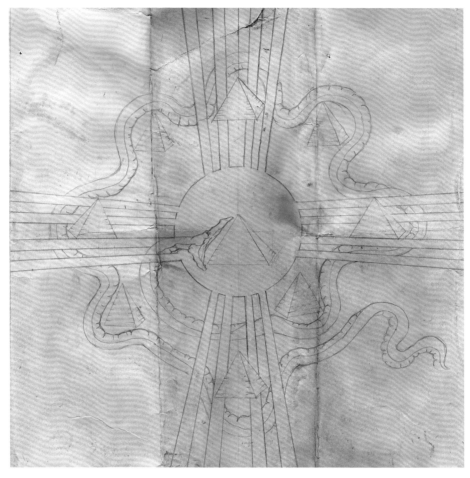

Artist unknown, Sketch for Saturn LP *The Soul Vibrations of Man*, c. 1977. Courtesy Chicago Jazz Archive, Special Collections Research Center, University of Chicago Library.

Lightned as in lightning. No gradual path of realization for Mr. Ra. Given that light is wisdom, enlightenment is not a gradual awakening, but something closer to the crack of a lightning bolt.

"Lightning" can sound a lot like "lightening" and that might be a word better left behind. A young Ra grew up surrounded by ads for skin whiteners and hair straighteners, products like "Tan Off" and "Shure White" and "Black No More." Even Garveyite publications like "Negro World" ran adds for these bleach creams. One black-owned Chicago company, Kashmir, had a series of Nile Queen advertisements that equated African American women's beauty with Ancient Egypt. However, the accompanying illustrations pictured women with light skin and straight or wavy hair, and other European features. By the 1930s the number of brand names for these whitening creams topped 200.[3]

History has been subject to a form of whitening as well. Ancient Egyptians have been routinely pictured as pale-skinned Europeans a la Cecil B. Demille. A parallel lightening can be seen in the histories of jazz and in the histories of civilizations as a whole with the Ancient Greeks attributed ideas that originated in Ancient Egypt.[4]

The question of the race of the Ancient Egyptians wasn't resolved until the International Cairo Symposium in 1974. Two African scholars, Cheikh Anta Diop and Theophile Obenga proved once and for all that Ancient Egyptians were not of western Asiatic or Caucasoid origin. They were black Africans. That doesn't mean that representations of Ancient Egyptians aren't still subject to bleach creams. Consider the recent King Tut touring exhibition and the new forensic renderings that depict him as a light-skinned caucasoid ruler.

When asked about his use of the term "Arkestra" Ra said that that's the way that the word "orchestra" sounds when somebody from Birmingham says it. Sure, there's Noah's boat and the Ark of the Covenant, but it's also the way a word sounds aloud. Similarly, that extra "en" in "enlightenment" might be left behind anyway when pronounced by somebody from Ra's earthly home town. Ra's biographer, John Szwed, writes "Sunny told the Arkestra that if you listened closely to people mispronouncing English words, you could hear the way that they said them made them sound like words in other languages. It was also possible to find phonetic similarities hidden behind the letters of the alphabet, to find words within words, to find contradiction within single words."[5] Like finding the word "lighten" in "enlightenment?" Or finding "enlight" and the path back to the fiery sun?

In Ra's broadsheet titled "The End," he writes:

> Lightning is the symbol of the Living Being. Life is a fire. Those who are dead have been snuffed out!!! The SUN is a living ball of fire.

He also writes: "Proper wisdom is enlightenment. It is the lightning that will enlighten the world." Only, that last enlighten has a third "en" added to the end. "Enlightenen" could be a typo. Maybe. Maybe not. Sun Ra liked balance and equations. If you take something from someplace, you have to account for it someplace else. Maybe that extra "en" was the same "en" removed from "enlightenment" in order to transform it into "enlightment."

"Proper wisdom is enlightenment. It is the lightning that will enlightenen the world."

1. Facsimiles of the broadsheets cited in this essay can be found in *The Wisdom of Sun Ra: Sun Ra's Polemical Broadsheets and Streetcorner Leaflets*, compiled and introduced by John Corbett (White Walls Inc.: Chicago, 2006).

2. Thanks to Robert Campbell for this numerological realization.

3. See Kathy Peiss, *Hope in a Jar: The Making of America's Beauty Culture* (Henry Holt and Co.: NY, 1998).

4. A popular book during Ra's Chicago years was George G.M. James' *Stolen Legacy: Greek Philosophy is Stolen Egyptian Philosophy* (1954).

5. John Szwed, *Space is the Place* (Pantheon: New York, 1997).

IMPULSE RECORDS

On a Clear Day I Wanna Do It a Different Way

BY ANTHONY ELMS

To start, an interview excerpt:

John McCracken: Esoteric ideas come in and out of focus. I'll be talking about UFOs or metaphysical things at a dinner party or something, and I note how long the conversations last. There will be some interest for 30 seconds or so and then, bang, it's off to something else. Sometimes it amuses me how little something can impinge. It reminds me of something Seth said about UFOs and how they appear. They have heavy pressures to buck when they show up in our atmosphere and they can only stay so long because they come from a different reality and it takes energy to stay visible in ours. So they come and go like those dinner conversations.

Dike Blair: You're sure it's not just people saying, "Oh no, here goes that UFO crank again?"

JM: Sometimes (laughs). Sometimes it's interest, too. I think my works may be similar to that. You've got a physical object that exists in different lighting conditions, environments and you're mixing different states and atmospheres of mind. So you have many possibilities for different kinds of perception. Sometimes my work looks like junk to me—stupid and brainless. And other times it looks like messages from the world I have interest in.

DB: Your works are optimistic.

JM: It seems to me that art has to be optimistic. I think art that isn't optimistic isn't art. It's difficult to figure out where the optimism may lie. Art can be disturbing but have a positive effect. I try to make art that is pretty obviously positive. I think in a possible future there is a world, or a number of them really, that is really great.

DB: Does technology bring us closer to spiritual perfection?

JM: I think it can. My impression of how some aliens may power their vehicles is that they use not only physical energy but also spiritual energy. You could have a vehicle that could move through dimensions and galaxies that would require a level of spirituality to work. That brings to mind the relationship of art to the viewer. Art doesn't just do things to the world, it is an element that needs something else to make it work.

This exchange comes from an interview Blair conducted with McCracken in 1998 for *Purple Prose*. In disclosure, I'll mention that this interview is compiled in a collection of Dike's writings WhiteWalls published.

The exchange between Blair and McCracken struck me as the place to begin not for the obvious reason—that McCracken speaks of UFOs and a techno-spiritual optimism, rather because this interview avoids what could have been a combative dismissive and circus-like back and forth. At no point does Blair fundamentally question McCracken's beliefs, at no moment does Blair demand a defense, and Blair never disrespects McCracken's logic. He merely requests clarity and further explication.

This is hardly the norm in revisiting interviews with Sun Ra. See, Ra is often put in that camp of acceptable crazy. Like Thelonious Monk, Cecil Taylor or George Clinton. Enjoyable music if you disregard the looniness in tow. To paraphrase Blair "Oh no, here goes that UFO crank again." I'm not a race scholar, and I am certainly not a jazz scholar, but I know condescension in the curl of a lip and the arch of an eyebrow. Or in print interviews, the implied tone of an italic.

In Chicago, concurrent with the pathways exhibition, art historian Huey Copeland and myself put together *Interstellar Low Ways*, it was less a comprehensive exhibition detailing the many ways Sun Ra has surfaced in visual art than a *friendschrift*, a gathering of friends, devotees and invested parties to celebrate the many paths by which Sun Ra means. Mysticism and expressionism, prophecy and placelessness, hermeneutics and racial politics, collectivity and counter-discourse, do-it-yourself myths and build-your-own futures. The exhibition was intended to be irreverent and cross-generational and not disrespectful. A competition of voices and methods of speaking with Ra.

Who has a right to speak. Me? I grew up in and around the Detroit area in the early seventies. Sun Ra hovered, if not in body in personage. It was sometime in the mid '80s before I knew he made music. I simply knew that Sun Ra was. A grand spirit. When I did learn he made music this hardly mattered, because I'd have had a greater chance of traveling to Saturn than finding the Saturn, ESP or Impulse LPs at a price I could afford. Ra remained a member of an antiestablishment council of elders that exerted cultural influence to many in the Detroit area. The MC5, Iggy Pop, Malcolm X, John Sinclair, George Clinton, Alice Cooper, and, due in part to a teaching stint at Michigan State University, the Art Ensemble of Chicago. Only Ra was harder to place because I couldn't really experience what he did at that moment.

This shifted slightly with the release of his A&M records in 1989 and '90, not known as two of Ra's best, and hardly indicative of his arc. Until Evidence began re-releasing a number of the prime records from the '50s and '60s in the early '90s, Ra was a very visually appealing myth. And there was a science to that myth, as could be gleaned from interviews with Sun Ra, which were easier to locate than his music and sufficed for some of us. Contemporary artists have been receptive to this fact, and followed this route accordingly. They do not disregard the philosophy; in fact, many prefer the message to the music. Still in this environment, as painter Glenn Ligon said in 2006:

> I think younger artists haven't dug deep into Ra's critique of American society. Those Faux-Egyptian/spaceman costumes are not just about spectacle (although they make for fantastic spectacle!), they're about using a mythic past and the notion

of the alien visitor to question the very category of "human," particularly as it relates to a people historically considered on the margins of what was considered "human."

We now accept Ra's music could not exist without his teachings, even if at times the focus is too heavy on the spectacle. Understandable I guess. Questioning what a white (or Hispanic, or Asian or African) artist might borrow from a black-American aesthetic: Which might you rather use? Crazy talk about being from Saturn and sequined costumes? Or hundreds of years of oppression and the resultant suppression of humanness? Of course, if it was just about the costumes, artists of every color and creed have elsewhere to turn. For this reason I purposefully want to sidestep Afrofuturism and other planes of there. I want to go against the vogue of celebrating Ra for his circus to concentrate on his function, "to question the very category of 'human.'"

How do you get the category of "human" to be your right? Who has a right to speak. And also, does that person with a right to speak also have the right to speak the way they desire to speak? This question is even more complicated by "…the tension felt by some contemporary people who are black and middle class and artists (for example) and who think (and wish) they can live their lives focusing on their interests…yet are called upon to consider social conditions and the past," to quote the artist Renee Green from her essay "Affection Afflictions: My Alien/My Self or More 'Reading at Work.'" Beyond class lines. Phrase that sentiment another way, artist David Hammons: "It's like listening to Sun Ra's music. It's so beyond blackness, it's so beyond whiteness. It's just beyond all of this. That's beautiful. I can get to that space if I decide to let loose some of this baggage, this cultural baggage that I've got. I got to get rid of it if I want to grow. Because I'm not going to get trapped into making cultural statements."

Whose cultural statements? Who strapped on the baggage? Who has a culture, and whose responsibility is it? What does it mean to be human, if someone else has the right to always turn your answers into cultural statements? If Ra is having a slowly expanding influence on visual art today, it is in part because the language used in dialogues on identities formed in art by the theory of the '80s and '90s seems to have not just calcified, but deteriorated in complexity and expansion over the last 10 years, leaving us wanting for more complicated bags to root through. As if to be entered into evidence as Exhibit A, Ra's presence is there, to prove the past and its social conditions, names and their definitions, can be creative tools to take us out of the cultural paths just as likely as they can record pasts that do not exist.

In a recent book on British industrial band Throbbing Gristle's album *20 Jazz Funk Greats*, from 1979, member Genesis P. Orridge is quoted, "all words are alive, in a literal sense. It's not just a metaphor. They have the ability to create and pressure people to bend and manifest agendas of those very words. Certain words are vying to control the direction of what you write." Sun Ra lived this, and Genesis has been vocal throughout his years in proclaiming the greatness of Ra. See, it isn't a question of whether or not Ra believed everything he said, he meant what he said. "*Sun Ra is not a person, it's a business name. And on the certificate, it's a business certificate which was*

gotten in New York City; they didn't notice that I didn't have down there what my business was. They stamped it, notarized it, and they filed it. So therefore, it's a business name, and my business is changin' the planet."

Now, I wish Sun Ra had been given more respect and attention for his views, his poetry, and his attempt to make all his creations paths of a more interesting proposal for what and who is on this earth. It didn't happen. I take consolation knowing that, in a way, distortion, disrespect and dismemberment are forms of conversation and create ways of saying: these thoughts matter. These beliefs affect my world, what the words represent have direct effect on what we are. Informs us that our calibrations for society may be inaccurate. In an interview from 2006: "Glenn O'Brien: Rock and Roll or Funk? Painter Christopher Wool: Funk or jazz?" This is for me the ultimate artistic question.

Pithy retorts. Scrambled codes. Contrarian directives. Punning. If Ra's words offered points of contention and provoked disbelief, this means our society needs to be different, and more importantly, Ra's words tells us that someone out there recognized this fact, and refused to speak according to rules and methods he found harmful. Ra insisted you had to meet him at least halfway. You want to talk beauty? Well, then you gonna talk about what it means to be human. You want to talk jazz? You gonna at least acknowledge that some out there might think there are better pasts than the one they were dealt. You want to talk history? Then you gonna talk about the kinds of spiritualism left off the official records. Ra's written and spoken announcements exemplify that, as science fiction author Samuel Delany wrote in the essay *Reading at Work*: "Critique—critical work—is created and constituted by people, by individuals, by individuals speaking and writing to others, by people who are always in specific situations that are tensional as well as technological."

This critique. Keeping the conversation focused on who is speaking, where they are speaking from, and what grammars, traditions and histories shape their language, whether or not they had to assert their right to speak, or could speak and assume a right—all find particular currency in contemporary art. All Delany's "people who are always in specific situations that are tensional as well as technological." Rewriting any ole tale as it is being told in order to maintain necessary tension.

Swedish artists Leif Elggren and Carl Michael von Hausswolff have worked both independently and collaboratively with each other and a number of other artists and musicians for over 30 years. In March of 1992, they proclaimed the founding of Elgaland-Vargaland, stating:

…we are annexing and occupying the following territories:

i - All border territories between all countries on earth, and all areas (up to a width of 10 nautical miles) outside all countries' territorial waters. We designate these territories our physical territory.

ii - Mental and perceptive territories such as the Hypnagogue State (civil), the Escapistic Territory (civil) and the Virtual Room (digital). The civil territories function as psychic and are self-contained. They appear in every citizen's mind, by will or by chance.

Further in the document they concluded:

As Citizens of The Kingdoms of Elgaland-Vargaland, we are immortal. There is no beginning and there is no end. We are all encouraged by this gift and basic privilege, we can all use it as a powerful tool and a fantastic opportunity to overcome and use fear, feelings of worthlessness and inferiority as well as hubris, megalomania and blind joy. To grow in reciprocal care and become those holy individuals we are meant to be.

Over the years Elggren and von Hausswolff have proclaimed all dead citizens of Elgaland-Vargaland, annexed Limbo and various demilitarized zones, and commissioned orchestras, individuals and folkloric groups around the globe to record the national anthem. Elggren and von Hausswolff proclaim themselves benevolent, all-powerful kings. Passports, stamps, flags, ministries, embassies and more have been created under direction of Kings Elggren and von Hausswolff since the constitution was written. Elgaland-Vargaland is an extended series of objects and performances concerning territorial ownership, the right to rule and the boundaries of individuals.

In their own words: "Elgaland-Vargaland is the largest—and most populous realm on Earth, incorporating all boundaries between other nations as well as Digital Territory and other states of existence. Every time you travel somewhere, and every time you enter another form, such as the dream state, you visit Elgaland-Vargaland." They promise that their right to rule covers only the physical and material manifestations of the Kingdom, having no power over the citizens, yet still, one needs to ask by what authority do they annex territories at will, and what offers them territorial ownership of my thoughts and states? And of course the obvious question: Are you serious?

Certainly there is humor and joking to Elgaland-Vargaland; after all, you are currently reading a text by the Consul General for Chicago. No, I'm not certain what my duties pertain.

During a lecture in Chicago, an audience member asked the obvious question verbatim: "Are you serious?"

To which von Hausswolff responded: "Sure. What is to be gained if I'm not serious?"

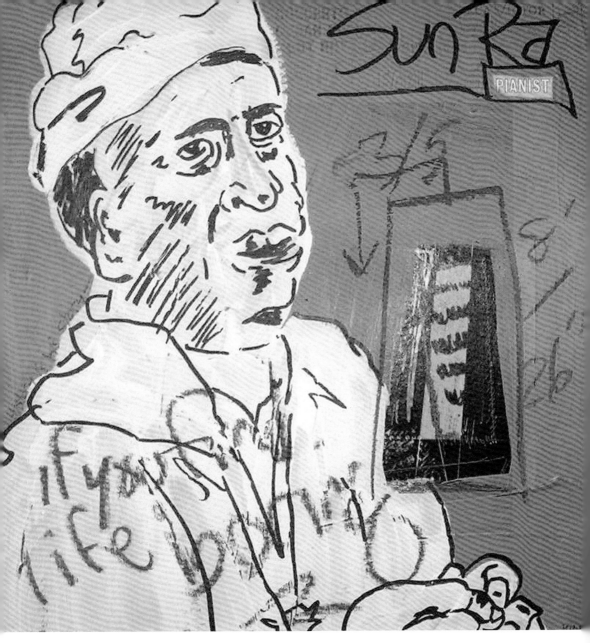

Tim Kerr, *Sun Ra*, mixed media on cardboard, 2009

Radical Utopia

BY MALIK GAINES

I.

In sci-fi novelist Octavia E. Butler's *Xenogenesis* trilogy, a sophisticated alien race cruises the universe searching for its future. This race, the Oankali, has a deep mind, but its material life-cycle depends upon finding a new species every once in awhile to breed with and absorb. In the first book, *Dawn*, a tall, strong black woman named Lilith is the protagonist who must face the radical possibility of mating with tentacled aliens. After the human race has destroyed itself and most of its planet with nuclear war, Lilith awakes in a space-ship lab where she discovers that she's been selected as original mother of the new hybrid beings. At first she's freaked out, but eventually she gets into it because, as we all know, Space is the Place. As the extremely intelligent, if physically repellent, Oankali see it, they saved a dying planet from destruction and have given its expired species the chance to recreate itself. These new beings will be different from humans in many ways, for example they have three genders, but in the end, the new blend is better than humanity was, especially in that these beings lack a death-wish. As in much of her writing, Butler shows us that the future is scary and bizarre, but that a black woman can take us there nonetheless and without fear. First she must accept hybridity, difference, radical technology, and other-worldly love. If she accepts these things, she can lead us out of our mess and into a new utopia.

II.

In her *Performing Science and the Virtual*, feminist performance theorist Sue-Ellen Case explores the white male myth of science in the western tradition, and begins to negate this white-coated symbology using alternate visions of what science can mean. In the chapter "Avatars of Synth-Race," Case cites Kodwo Eshun's *More Brilliant than the Sun: Adventures in Sonic Fiction*, in which the writer describes Afrodiasporic music traditions as a "sciencemyth" "that sets up an interface between science and myth... a continuum from technology to magic and back again." "Synthrace" is the term Eshun uses to describe the process of recoding racial identity through science and technology, as in Sun Ra's afro-futurist project. Case explores Sun Ra further in the context of this and other concepts. Citing a scene from *Space is the Place*, Case writes:
Sun Ra addresses the youth in the ghetto saying "I hate your absolute reality." For him, "reality" is simply the vain show of subjection, which they can evacuate through the synthesized outer-space. This virtual space can interpolate itself into the ghetto as a utopic condition that could become immediately realizable. As an avatar of a Pharaonic "synthrace," Ra could perform, through the media of jazz and movement, how an alternative life might appear. Interpolating the crystal in the midst of an anti-racializing dialog, Sun Ra emphasizes his power to move race from its historical determinants to rest in mystical powers. "If you're already a myth," he instructs, "why not embrace one of power and glory."

III.

The work I do with my collaborators Alexandro Segade and Jade Gordon under the name My Barbarian, has been an attempt to envision new utopic mythologies that appropriate history and political reality and reframe them for our own theatrical use. Our sincere yet campy musical spectacles serve as rituals to exorcise the present of its destructive history. Using a lo-fi sensibility, but within the context of new technology that allows us to cheaply make music recordings and movies on video, My Barbarian performs a space in which our own hybrid identities and interdisciplinary formal practice turn fantasies into reality. Our movie *Pagan Rights* (2006), currently on view in the California Biennial at the Orange County Museum of Art, draws from a stage show we wrote as an entertaining counter-weight to the oppressive Christian right that has ruled so decisively over the six years that we've been working together as a group. Exploring some of the counter-cultural aesthetics of our parents' generation, we fantasize about the various communities we might create to survive the onslaught of dangerous morality. In this piece, artists like Sun Ra figure as prominent examples of what's come before us. Despite the fact that these creative and political movements did not defeat capitalism, end racism, etc., we use them as models for a way to imagine the present we'd rather live in and hopefully affect the future in our own way.

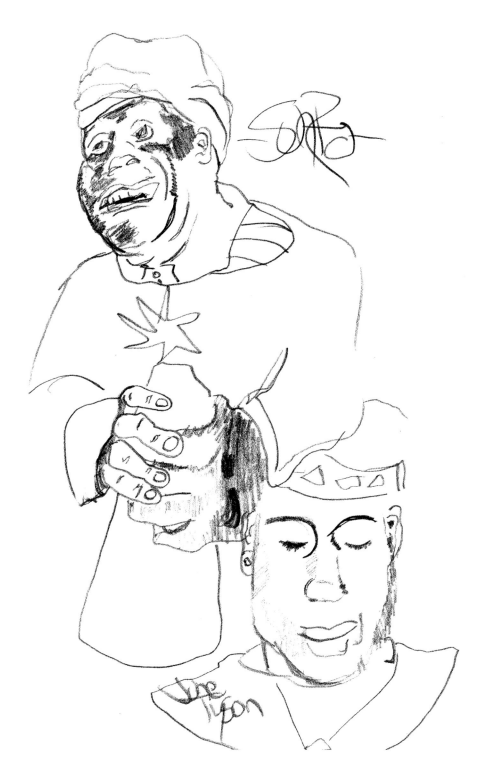

Tim Kerr, , *Sun Ra and June Tyson*, graphite on paper, 2009

SUNRA for PRESIDENT

or
JOHN
KERRY
and
GANDALF

Sun Ra—Founding Father of "Psychic Secession"

BY KARL ERICKSON

Though psychic secession was not a widely acknowledged or codified practice during his earthly tenure, Sun Ra can be considered one of its most important historical pioneers—part of a distinguished pantheon that includes Kubla Khan and Howard Hughes.

Through his work, dress and deeds, Sun Ra separated himself from the majority of humanity—indeed, he insisted that he was born on the planet Saturn and sent to earth to liberate its inhabitants. Bound by no nation nor compact of wills, Sun Ra bent the rules of belief and objectivity. His music and performances were and are not mere entertainment—nor can they be considered "free-jazz calisthenics." Rather, they are tightly-orchestrated rituals of emancipation from dominant, oppressive, sterile governance. Following the sounds and acts of Sun Ra, one is required to loosen one's grip on the known, the weighted and grounded—indeed to free oneself from all previously-defined notions of the acceptable.

Through his actions, Sun Ra is an example to be held aloft as glowing, Gandalfian florescence in this—the darkest of times. Follow the spaceways and slip free into your own mental firmament—away from the jackboots of time and the tyranny of "leaders."

(facing) Karl Erickson, *Sun Ra for President*, 2004. Screen print, 11" x 17"

(above) Karl Erickson and Robby Herbst, *Every Color is Different As Ever Different Thing is Different*, 2006. Video installation, 02:16, dimensions variable. With Thomas McKenzie, Liz Anderson, Jill Newman, and Eric Niebuhr

===============WEEDS/travis (1995-1996)
Every time I See you naked I Offer my death bed but
You won't take it
Strange, my flower bed cannot hold you.
In my prime I Tried to burn away my Winter weeds but I
Breed and then I decay
Strange, my flower bed cannot hold you.
Strange, some ghostly deed exposed my fangs
And all my lilies turn to seed
Strange, my flower bed cannot hold you.

===============THE MODEL BRIDE/travis (1979/1980)
Date: 914792000
LengthEssex: 2000
PartNumber: 40690-10
21degrees+centigrade+white+hot+industrial
industrialthermoherniation
pain!pain!pain!

 romeo/xray51coaxialcable
pain!pain!pain!
AntiMode!
south7-1-4-0-7
 amazonelectromyographicworkereel 16years
bravo!bravo!bravo!

TheModelBride. TheModelBride. TheModelBride.

travis, set list, 2010

Remember the Revolution?

BY GLENN LIGON

When I was thirteen, I fell in love with a pair of white vinyl boots. My Uncle Donald, who was my mother's brother and the youngest of eleven children, wore them. Chocolate handsome and stylish in his wide collared shirts and flared double-knit pants, toothpick at a rakish angle between his lips, Donald was everything. His house was a player's dream: orange silk couch with a built-in stereo system flanked by two enormous gold Buddha-head lamps; a black lacquer coffee table that could be raised or lowered depending on whether it was time for a game of Spades or Chinese food; and wall-to-wall, two-tone, brown shag carpet that no shoes had ever touched and that was meticulously raked every time Donald left the apartment. Donald was so stylish in his maroon Buick Riviera that no one would have known his day job was at the Lammond-Riggs Post Office on North Capital Street, in Washington, DC, and, like many black people of his generation, he seemed to embody worldliness although he hadn't really been nowhere.

For all of his fascinating qualities, my obsession with Uncle Donald coalesced around his white vinyl boots. It was 1974 when everything changed for me. Nixon had resigned, the troops were coming home from Vietnam, and at age thirteen, my nascent mustache finally started to fill out. It was also the year when I realized that I was not going to be quite like other boys and that I needed a new paradigm for how to be this person I was becoming. I found that new paradigm in a pair of boots. White vinyl boots were both the future and the past. They were the cool, hygienic, extraterrestrial whiteness of space in movies like *Logan's Run* or *2001: A Space Odyssey*, and they harked back to the outfits worn by doo-wop groups, Sonny and Cher, and Little Richard. White vinyl was the frontier of masculinity. It signaled that the wearer was unconcerned with trivialities such as gender and sexuality, that he had reached higher ground. In my adolescent mind those were the boots we would wear when we, as a people, marched into the Promised Land, and I had to have a pair.

My mother, already worried about my Proustian tendencies, was reluctant to indulge this fashion trajectory until I persuaded her that if Uncle Donald—masculine, happily married Uncle Donald—had a pair of white vinyl boots then surely it was OK for me to have some, too. When I finally got a pair and tried them on at home in front of the hall closet mirror I looked ridiculous, as if I were wearing galoshes bought in some shrimp fisherman's supply store. Just three outings in those boots, with double takes from adults on the street and ridicule from my classmates, convinced me to retire them to the back of my closet, before eventually donating them to the needy at a clothing drive at our local church.

It took me years to even attempt wearing anything so fashion-forward again, and by that time, from my vantage point in The Forest Projects, South Bronx, USA, I could see the winds of change were blowing, and what they were blowing was a whole new version of black masculinity in the form of the Sugarhill Gang, Run DMC, and Grandmaster Flash, who were not above a bit of glam, but whose lyrics and body language left no room for gender ambiguity or play. Donald, at this point solidly middle-aged and starting to gray around the temples, had long retired his knits and white vinyl

for leisure suits and what he called "kicks," comfortable rubber soled shoes with canvas uppers you could buy at K-Mart. He died a couple of years ago, worn out from living in the bottle, and I'm still waiting for whatever utopian world those white vinyl boots promised me in 1974. I still remember those boots. I still remember the future.

In the 1974 film *Space is the Place*, Sun Ra, ambassador of the intergalactic regions of outer space, teleports into a youth center in Oakland, California. With his gold chain-mail headdress, multicolored robes, red corduroy pants, and *Curse of the Mummy* bodyguards, Ra isn't clearly from the future or from the past, nor, as one of the kids jokingly observes, is he just some hippie from Telegraph Avenue. Much attention is paid in the scene to Ra's shoes: huge, silver and gold–striped lace-ups, which the kids call "moon boots." That seems apt, since Ra teleports into those shoes, which appear at the youth center several seconds before he does—footwear as a vehicle for intergalactic transport. Like my uncle's white vinyl boots, which offered me a whole new way to think about my possibilities in the world, Ra's shoes offer a link to different realities and modes of being, a link to the space age. Of course, shiny transporting shoes are nothing new, Dorothy's ruby slippers being just one well-known example. But Dorothy's shoes took her home, while Ra's transport him to and from spaces not located in any particular time or place. As he says to the kids at the youth center, "I came from a dream that the black man dreams long ago. I'm actually a present sent to you by your ancestors." Ra came from a dream, to take them to a dream, to prepare them for the future: the not-so-distant year 2000.

Much more could be said here about this scene from *Space is the Place*: How the youth center functions as a little utopia where brothers and sisters can relax and conversate under the inspiring gazes of Frederick Douglas, Malcolm X, Martin Luther King, Jr., Huey Newton, Eldridge Cleaver, and Angela Davis; how the blue and black platform shoes worn by the drunken man at the beginning of the scene, in contrast with Ra's shoes, are vehicles that take the drunkard nowhere; how the glasses that one of the kids puts on are equated with the crystal that Ra presents them and that allows them to see and hear the Arkestra—but let me try to address the question posed to me when I was invited to deliver this lecture: Why are young artists into Sun Ra today?

There is no single simple answer but several possibilities come to mind. The first is that no one believes in the future anymore, but we still believe in representations and representatives of it. Just as the movie *2001: A Space Odyssey* might still represent the future, so might Sun Ra. His refusal of the category "human," his interest in communal practices and improvisation, his embrace of pop culture and kitsch, his passionate critique of American society—all these qualities represent a resonant moment that can be brought into the present.

Another reason for Sun Ra's enduring relevance might be suggested by the writings of Jean Genet. In his book *Prisoner of Love*, Genet says the Black Panthers were "a great wind [that] swept over the ghetto, carrying away shame, invisibility, and four centuries of humiliation. But when the wind dropped people saw it had been only

a little breeze, friendly, almost gentle." In opposition to the Panthers, Genet locates the real revolution in America within the love between people of differently colored bodies. While leaving aside his characterization of the impact of the Panthers, I'm interested in the suggestion that revolutions should not be televised, that they need to remain underground, fugitive, idiosyncratic, quiet, that they only unfold over time. Sun Ra represents such a model for a (black) velvet revolution, one not tied to any particular political system or definable ideology.

One more reason that Ra might still speak to young artists has to do with lightness. Commenting on the role of the shaman in *Six Memos for the Next Millennium*, Italo Calvino writes, "Faced with the precarious existence of tribal life— drought, sickness, evil influences—the shaman responded by ridding his body of weight and flying to another world, another level of perception, where he could find the strength to change the face of reality." Ra's interest in flight is a kind of politics. Being light is a refusal of the limitations of what is considered human. As Kodwu Eshun has pointed out in his book *More Brilliant Than the Sun*, the human has always been a treacherous category for black people to embrace, given our historic exclusion from that domain. Ra's refusal of the real in favor of myth, his willful collapsing of different historical moments, and the nimbleness of language in his writings are all in service of lightness. To be light, to be able to fly away, is to be able to imagine something beyond what we see. What we see right now is pretty grim, so Ra's ability to see beyond his particular historical moment as a way to change it remains compelling.

Ra was acerbic, complicated, punning, and strange, but he was never cynical. The future is what we invent; Ra believed what he invented; and the fact of that faith is appealing and inspiring. Although I said these days we believe only in the future's representatives and representations, perhaps what we believe in most about the future are those like Sun Ra who truly believe in it.

Let me close with what I remember of tomorrow:

I remember, "If you're black, get back."

I remember, "Go back to Africa."

I remember, "No Place to be Somebody."

I remember, "It's an everyday thang … in the ghet—to."

I remember, "In my neighborhood there used to be some beautiful black men that would come through the neighborhood dressed in African shit, you know, really nice shit, you know, and they'd be, 'Peace. Love. Black is beautiful. Remember the essence of life. We are people of the universe. Life is beautiful.' And my parents go, 'That nigger crazy.'"

I remember *Logan's Run*. "I went to see *Logan's Run*, right? They had a movie of the future called *Logan's Run*? There ain't no niggers in it! I said, 'Well white folks ain't planning for us to be here!'"

I remember, "People get ready, there's a train a-coming."

I remember, "I got soul and I'm super bad."

I remember, "Say it loud ... I'm black and I'm proud."

I remember not being able to say, "Say it loud... I'm black and I'm proud."

I remember, "Niggers are scared of revolution."

I remember, "The revolution will not be televised."

I remember, "Free sister Assata Shakur."

I remember, "Bang, bang, boom, boom, Ungowa. Black power."

I remember Afro Sheen.

I remember, "Back to Africa."

I remember, "What's the word? ... Johannesburg!"

I remember reparations.

I remember, "People helping people."

I remember Soul City, North Carolina.

I remember "Push On, Jesse Jackson."

I remember, "Bean pie, my brother?"

I remember The Mothership Connection.

I remember, "Chocolate city and its vanilla suburbs."

I remember Psychoalphadiscobetabioaquadoloop.

I remember, "We love you Doctor Funkenstein, your funk is the best."

I remember Patti Labelle, Nona Hendrix, and Sarah Dash in silver lamé bodysuits.

I remember Trans Europe Express.

I remember, "Ich, Ni, San, Shi."

I remember Cerrone and "Supernature."

I remember Boney M.

I remember, "Rock, rock the planet rock."

I remember, "I Feel Love."

I remember the future.

S U N R A

.: :. BY TAM FIOFORI

TAM FIOFORI: HOW DO YOU FEEL ABOUT THE MOON SHOT , IN THE LIGHT

OF YOUR SPACE MUSIC ?

SUN RA: WELL , I AM NOT PLAYING SPACE MUSIC AS THE ULTIMATE
REACH ANY MORE , THAT IS ,NOT IN THE INTERPLANETARY SENSE ALONE .
IAM PLAYING INTERPLANETARY MUSIC, WHICH IS BEYOND THE OTHER IDEA
OF SPACE MUSIC , BECAUSE IT IS OF THE NATURAL INFINITY OF THE
ETERNAL UNIVERSE UNIVERSES AND ALL THE UNIVERSES TOGETHER MAKE
ANOTHER KIND OF UNIVERSE . THERE IS A NEED FOR THAT TYPE OF BEINGNESS
UPON THIS PLANET AT THIS TIME . THE SPACE MUSIC OF THE PREVIOUS
YEARS WAS PRESENTED TO PREPARE PEOPLE FOR THE IDEA OF GOING TO
THE MOON AND OTHER PLACE LIKE THAT IN THE INTERPLANETARY THING ,
BUT NOW , SINCE THAT HAS BEEN ACCOMPLISHED , OF THE IDEA THAT
HAD BEEN PROJECTED ARE PROPOGATED' THEN OFCOURSE ,,
THERE IS NO NEED FOR ME TO PROPOGATE IT MYSELF ; SINCE SOME-
BODY ELSE IS DOING IT . I DONT LIKE DOING OTHER THINGS OTHER
PEOPLE DO , AT LEAST OF THE SAID PROJECT , IF IT DOES NOT
NECESSARILY NEED THE TWO OF US ; BECAUSE TO DO SO UNDER THOSE
CIRCUMSTANCES WOULD WASTE MY TIME , OR SEEM TO AT ANY RATE .
I LIKE TO DO THINGS THAT ARE NATURAL FOR ME TO DO , THAT OTHERS
CAN'T DO OR ARE NOT READY TO DO AT THAT OR THIS POINT .OFCOURSE
THERE IS ALWAYS THE POSSIBILITY OF AN EXCEPTION TO THE RULE ,
AND THERE ARE DIFFERENT RULES FOR DIFFERENT EQUATIONS
AT DIFFERENT TIMES AND DIFFERENT SPACES FOR THIS IS A VAST UNIVERSE
AND A VAST INFINITY . ON THIS PLANET IT SEEMS TO HAVE BEEN
VERY DIFFICULT FOR ME TO DO AND BUILD THE PROPER THINGS AND
PROJECTS . AS I LOOK AT THE WORLD TODAY AND ITS EVENTS AND
ODDEST OF THE POSSIBLE THINGS , I LIKE THE IDEA OF THE IMPOSSIBLE
THINGS MORE AND MORE . I SPOKE OF THE IMPOSSIBLE RECENTLY IN
ESQUIRE MAGAZINE IN CONNECTION WITH THE MOON SHOT WHEN I STATED:
"REALITY HAS TOUCHED AGAINST MYTH/HUMANITY CAN MOVE TO ACHIEVE
THE IMPOSSIBLE/CAUSE WHEN YOU ACHEIVE ONE IMPOSSIBLE THE
OTHERS/COMES TOGETHER WITH THEIR BROTHER , THE FIRST IMPOSSIBLE
IMPOSSIBLE/BORROWED FROM THE REALM OF THE MYTH/HAPPY SPACE
AGE TO YOU" . SO NOW I AM ON MY INFINITY IMPOSSIBLE AS TO WHAT
AND WHICH I AM GOING TO DO , AND TO WHAT AND WHICH I AM NOT
GOING TO DO , BECAUSE IT DEALS WITH THE IMPOSSIBLE , THE WORLD
OF "NOTS". IT GETS VERY INVOLVED WHERE YOU CANNOT EXPLAIN IT TO
PEOPLE WHO ARE NOT SPIRITUAL-MINDED IN AN ADVANCED SENSE ; OR
WHO HAVE NOT HAD THE EXPERIENCE OF PRECISION DISCIPLINE ; OR WHO
HAVE USED THEIR TIME DOING OTHER THINGS,OTHER THAN THE STUDY
AND THE BEING-EXPERIENCE OF SPIRITUAL EVOLUTION ACHIEVEMENT...

Interview transcript, c. 1969. Courtesy Chicago Jazz Archive, Special Collections Research Center, University of Chicago Library.

Contributors

CHERYL LYNN BRUCE is an actor and director based in Chicago. Her direction of Congo Square Theatre's 2001 production of *From the Mississippi Delta* garnered both the African American Arts Alliance and the Black Theatre Alliance award for Best Direction. A co-founding Director of the Goodman Theatre's Youth Drama Workshop for eight years, Bruce now heads a new initiative, Dearborn Homes Youth Drama Workshop, for residents of 10–18 years of age. Bruce has appeared on stage at Lookingglass Theatre, Goodman Theatre, Steppenwolf Theatre, Victory Gardens, Huntington Theatre, La Jolla Playhouse, the Kennedy Center, Crossroads Theatre, Shakespeare Repertory, and more, as well as in numerous television and film appearances. She has also taught and directed at the University of Illinois at Chicago and DePaul University.

ROBERT L. CAMPBELL is a Professor of Psychology at Clemson University. He has served as a record reviewer for *Cadence* magazine, operates a website on jazz and R&B in Chicago (www.redsaunders.com), and has published on Chicago music in *Goldmine and Blues & Rhythm*. He is the co-author (with Christopher Trent) of *The Earthly Recordings of Sun Ra*.

PHILIP COHRAN is a trumpeter, multi-instrumentalist, and composer based in Chicago. In the mid-1960s, he was co-founder of the Association for the Advancement of Creative Musicians (AACM), ran the Affro-Arts Theatre, and formed his own ensemble, the Artistic Heritage Ensemble. Cohran was a member of the Sun Ra Arkestra from 1958 to 1961.

JOHN CORBETT is a curator and writer based in Chicago, where he teaches at the School of the Art Institute. He is cofounder of Corbett vs. Dempsey Gallery and producer of the Unheard Music Series. In 2002, Corbett was Artistic Director of JazzFest Berlin. He writes for *Down Beat* magazine and has recently contributed essays to catalogs for artists Jim Lutes and Albert Oehlen.

DEPARTMENT OF GRAPHIC SCIENCES is a design studio in Chinatown, Los Angeles headed by Liz Anderson and Kimberly Varella. With a focus on print design for arts organizations and non-profit institutions, the studio's recent projects include *An Atlas of Radical Cartography* (Journal of Aesthetics & Protest Press, 2007), and *Machine Project: A Field Guide to the Los Angeles County Museum of Art* (Machine Press, 2009). To see their work, please visit www.deptofgraphicsciences.com.

ANTHONY ELMS is an artist and writer. Elms is also the Editor of WhiteWalls, and Assistant Director of Gallery 400 at the University of Illinois at Chicago. With Gallery 400 he has curated and/or organized thirteen exhibitions. His writings have appeared in *Art Asia Pacific*, *Art Papers*, *Artforum*, *Cakewalk*, *Coterie*, *Interreview.org*, *May Revue*, *Modern Painters*, *New Art Examiner*, and *Time Out Chicago*; as well as many exhibition catalogs. As an artist, Elms' works have been included in projects exhibited at Gahlberg Gallery (Glen Ellyn), Mandrake (Los Angeles), and Western Exhibitions (Chicago), among others.

KARL ERICKSON is an artist based in Brooklyn. His interests include transcendental experiences, motivational language, psychedelia, and counter-cultures throughout the ages. His primary media are video, posters, collage and latch-hook rugs and pillows. Recent exhibitions include "Be Almost Miraculous", Sea and Space Explorations (Los Angeles); "Give the Past the Slip" (with Andrew Falkowski), The Suburban (Chicago); "This Shadow is a Bit of Ideology", Gallery 400 (Chicago); and "Louis Morris," Atlanta Contemporary Art Center. With artist Robby Herbst and Steve Anderson, Erickson makes psychedelic liquid lights shows. Recent performances have taken place at High Energy Constructs, the LA Country Fair, and Outpost (all Los Angeles).

CALVIN FORBES is the author of *The Shine Poems* (LSU Press); *Blue Monday* (Wesleyan University Press); and essays and fiction in many journals. He teaches Literature, Creative Writing, and the Social History of Jazz and Blues at the School of the Art Institute of Chicago.

MALIK GAINES is a writer and performer based in Los Angeles. Gaines performs with the group My Barbarian, which has presented experimental musicals internationally, at venues including the REDCAT and the Hammer Museum (Los Angeles); Participant, Inc. (New York); De Appel (Amsterdam); The Power Plant (Toronto); Peres Projects (Berlin); El Matadero (Madrid); and the Aspen Art Museum. My Barbarian was included in the 2005 Performa Biennial, the 2006 California Biennial, the 2007 Montréal Biennale, and again at the 2007 Performa Biennial with a performance at the Whitney Museum of American Art. Gaines has written arts journalism and criticism for numerous publications and exhibition catalogs, and has taught courses at CalArts, UC Irvine, California College of the Arts, and others.

TERRI KAPSALIS is the author of *The Hysterical Alphabet* (WhiteWalls) and *Public Privates: Performing Gynecology from Both Ends of the Speculum* (Duke University Press) and the co-editor of *Pathways to Unknown Worlds: Sun Ra, El Saturn & Chicago's Afro-Futurist Underground, 1954–1968* (WhiteWalls). As an improvising violinist, Kapsalis has a discography that includes work with Tony Conrad and Mats Gustafsson. She is a founding member of Theater Oobleck, works as a health educator at Chicago Women's Health Center, and teaches at the School of the Art Institute of Chicago.

GLENN LIGON is an artist based in New York. His paintings and works in other media embody complex questions of identity, representation and language. Ligon is best known for text-based paintings that appropriate material from black-themed coloring books, the jokes of Richard Pryor, and the writings of James Baldwin, Gertrude Stein, Zora Neale Hurston, and others. He treats these texts and images as material, allowing them to function both physically and conceptually and to destabilize our assumptions of race, sexuality and of our place in the world. He exhibits regularly with Thomas Dane Gallery (London) and Regen Projects (Los Angeles). A recent film project based on Thomas Edison's version of *Uncle Tom's Cabin* includes an original score by pianist Jason Moran. In 2011 Ligon will release *A People on the Book* with WhiteWalls.

GRAHAM LOCK is a freelance writer who lives in the UK. He is co-editor of *The Hearing Eye* and *Thriving on a Riff*, two collections about jazz and blues influences in African American visual art, literature and film (both Oxford University Press). His other books include *Blutopia*, about the music of Sun Ra, Duke Ellington and Anthony Braxton as alternative history (Duke University Press); and the Braxton-UK-tour classic, *Forces in Motion* (Quartet).

VICTOR MARGOLIN is Professor Emeritus of Design History at the University of Illinois, Chicago. He is a founding editor and now co-editor of the academic design journal *Design Issues*. Books which he has written, edited, or co-edited include *The Struggle for Utopia: Rodchenko, Lissitzky, Moholy-Nagy, 1917-1936*; *Design Discourse*; *Discovering Design* (all University of Chicago Press); and *The Idea of Design* (MIT Press). His most recent books are *The Politics of the Artificial: Essays on Design and Design Studies* (University of Chicago Press), and *Culture is Everywhere: The Museum of Corn-temporary Art* (Prestel). He is currently working on a world history of design.

KERRY JAMES MARSHALL is an artist living in Chicago. He received a BFA from the Otis Art Institute in Los Angeles, from which he received an honorary doctorate in 1999. Marshall's work has been exhibited in group shows in the United States for over twenty years and in international exhibitions such as documenta X, Kassel. Solo exhibitions of his work have been presented at the Studio Museum in Harlem, New York (1986); the Renaissance Society at the University of Chicago (1998), and many others. In 2003, the Museum of Contemporary Art Chicago organized *Kerry James Marshall: One True Thing, Meditations on Black Aesthetics*, a major touring retrospective of his work. In 1997 Marshall was awarded a John D. and Catherine T. MacArthur Foundation fellowship.

KEVIN WHITEHEAD is the longtime jazz critic for NPR's "Fresh Air," and the author of *New Dutch Swing* (Billboard Books) and *Jazz: What Everyone Needs to Know* (forthcoming). He has taught at the University of Kansas and Goucher College. Whitehead saw Sun Ra perform many times, starting in the 1970s. He once invoked the ire of one of Sun Ra's minions by trying to return a warped El Saturn LP. "What do you want, a record that's as flat as the planet Earth?"